OSA & SOUTH PACIFIC

COSTA RICA REGIONAL GUIDES

Diego Arguedas Ortiz and Luciano Capelli

AN OJALÁ EDICIONES & ZONA TROPICAL PUBLICATION
from
COMSTOCK PUBLISHING ASSOCIATES
an imprint of
CORNELL UNIVERSITY PRESS
ITHACA AND LONDON

First published 2020 by Cornell University Press

Printed in China

Library of Congress Cataloging-in-Publication Data

Names: Arguedas Ortiz, Diego, author. | Capelli, Luciano, author.
Title: Osa and South Pacific / Diego Arguedas Ortiz and Luciano Capelli.
Description: Ithaca [New York] : Comstock Publishing Associates, an imprint of Cornell University Press, 2020. | Series: Costa Rica regional guides | Includes index.
Identifiers: LCCN 2020015067 | ISBN 9781501752858 (paperback)
Subjects: LCSH: Natural history—Costa Rica—Osa Peninsula.
| Osa Peninsula (Costa Rica)—Description and travel.
| Parque Nacional Corcovado (Costa Rica)
Classification: LCC F1549.O83 A74 2020 | DDC 917.2/8604—dc23
LC record available at https://lccn.loc.gov/2020015067

Front cover photo: Luciano Capelli
Back cover photo: Luciano Capelli

COSTA RICA REGIONAL GUIDES

The world knows Costa Rica as a peaceful and environmentally conscious country that continues to attract several million tourists a year, yet this image may obscure a social and biological legacy that very few visitors get to know.

We hope that the six books in this collection will reveal a reality beyond the apparent one. These are meant to pique the curiosity of travelers through stories about nature, geology, history, and culture, all of which help explain Costa Rica as it exists today.

Each title is dedicated to those who fought, and continue to fight, with grace and wisdom, for a natural world that lies protected, in a state of balance, and accessible to all—in other words, one that is closer to the ideal we seek to make real.

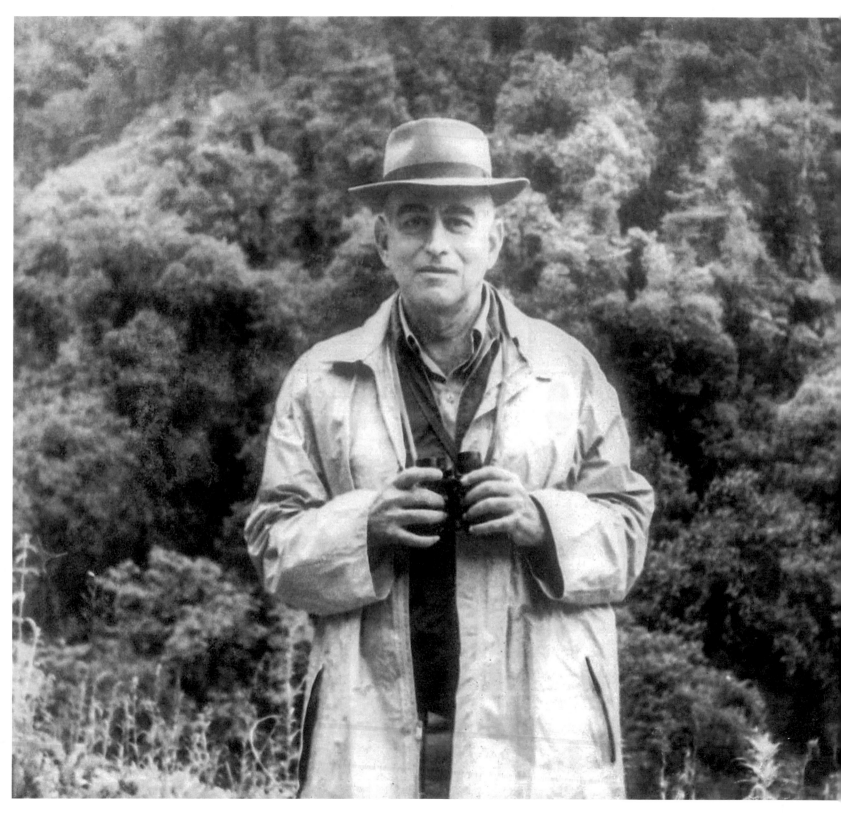

DEDICATION

ALEXANDER SKUTCH

Dr. Alexander Skutch was one of the world's great tropical naturalists. His love of the Valle del General, its people, and the Talamanca Mountain Range began in 1935 when he moved there to collect botanical specimens and study birds. First, he lived in a rustic cabin in the village of Rivas, then moved around the region until 1941 when he purchased Los Cusingos farm in Quizarra. He resided there until his death in 2004, eight days before his 100th birthday. At Los Cusingos he raised a family, grew most of his food, bathed at a nearby river, and dedicated most of his life to studying birds and writing over 30 books and 200 articles on ornithology, conservation, and philosophy.

In 1971, when there were only three public protected wildlands in Costa Rica, I assisted Alexander and Drs. Joseph Tosi and Leslie Holdridge in conducting an inventory of future Costa Rican national parks and equivalent reserves. Because Alexander rarely left Los Cusingos, I visited him for his input. He insisted that Talamanca and particularly Chirripó be preserved for their biodiversity, especially the endemic turquoise cotinga (*Cotinga ridgwayi*) and water and oxygen resources. Those areas now form part of one of Central America's most important contiguous protected areas and are featured in this book. His legacy survives there and on his endeared Los Cusingos farm, where his remains rest among birdsong and running water.

Christopher Vaughan, PhD

CONTENTS

DEDICATION
ALEXANDER SKUTCH

Dr. Alexander Skutch was one of the world's great tropical naturalists. His love of the Valle del General, its people, and the Talamanca Mountain Range began in 1935 when he moved there to collect botanical specimens and study birds. First, he lived in a rustic cabin in the village of Rivas, then moved around the region until 1941 when he purchased Los Cusingos farm in Quizarra. He resided there until his death in 2004, eight days before his 100th birthday. At Los Cusingos he raised a family, grew most of his food, bathed at a nearby river, and dedicated most of his life to studying birds and writing over 30 books and 200 articles on ornithology, conservation, and philosophy.

In 1971, when there were only three public protected wildlands in Costa Rica, I assisted Alexander and Drs. Joseph Tosi and Leslie Holdridge in conducting an inventory of future Costa Rican national parks and equivalent reserves. Because Alexander rarely left Los Cusingos, I visited him for his input. He insisted that Talamanca and particularly Chirripó be preserved for their biodiversity, especially the endemic turquoise cotinga (*Cotinga ridgwayi*) and water and oxygen resources. Those areas now form part of one of Central America's most important contiguous protected areas and are featured in this book. His legacy survives there and on his endeared Los Cusingos farm, where his remains rest among birdsong and running water.

Christopher Vaughan, PhD

CONTENTS

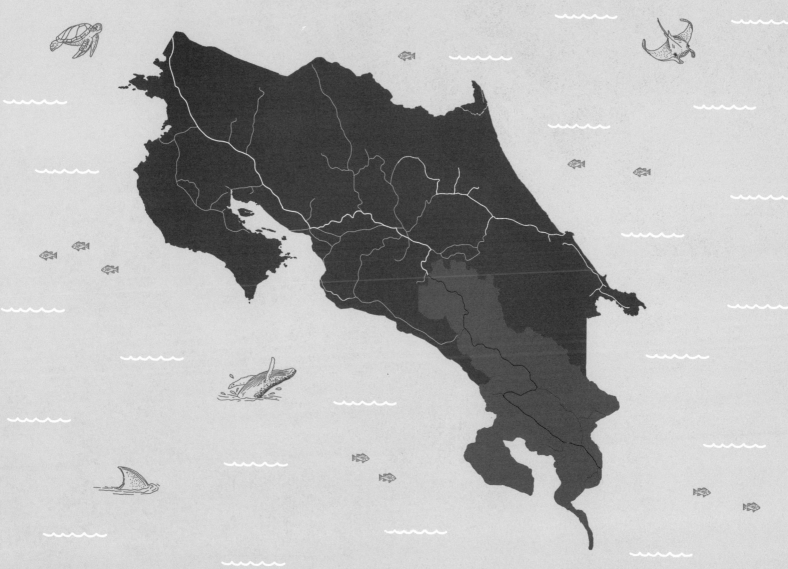

OSA & SOUTH PACIFIC

COSTA RICA ≋ REGIONAL GUIDES

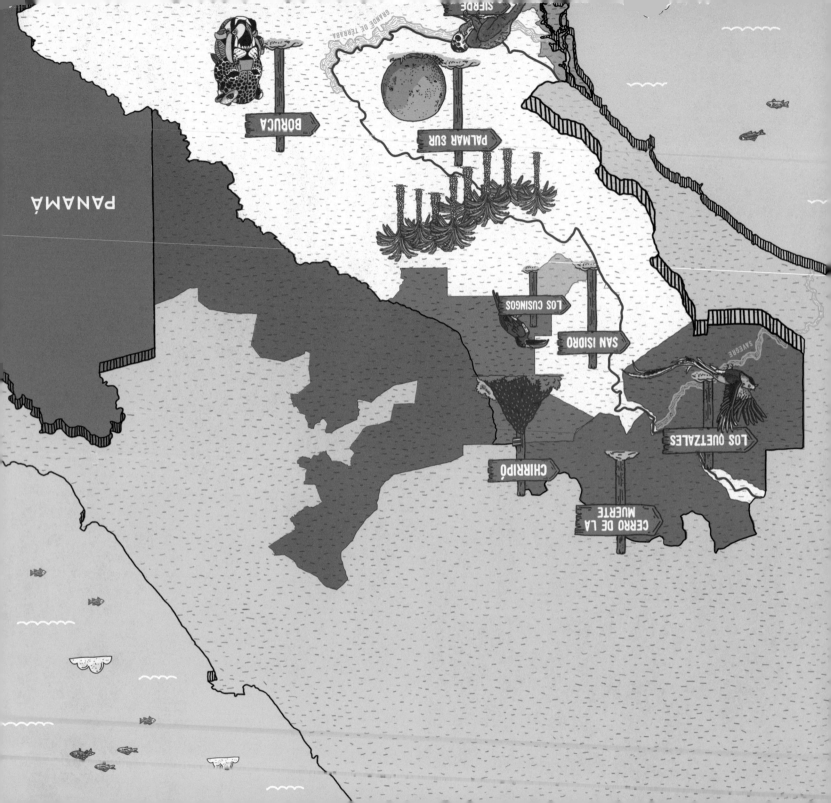

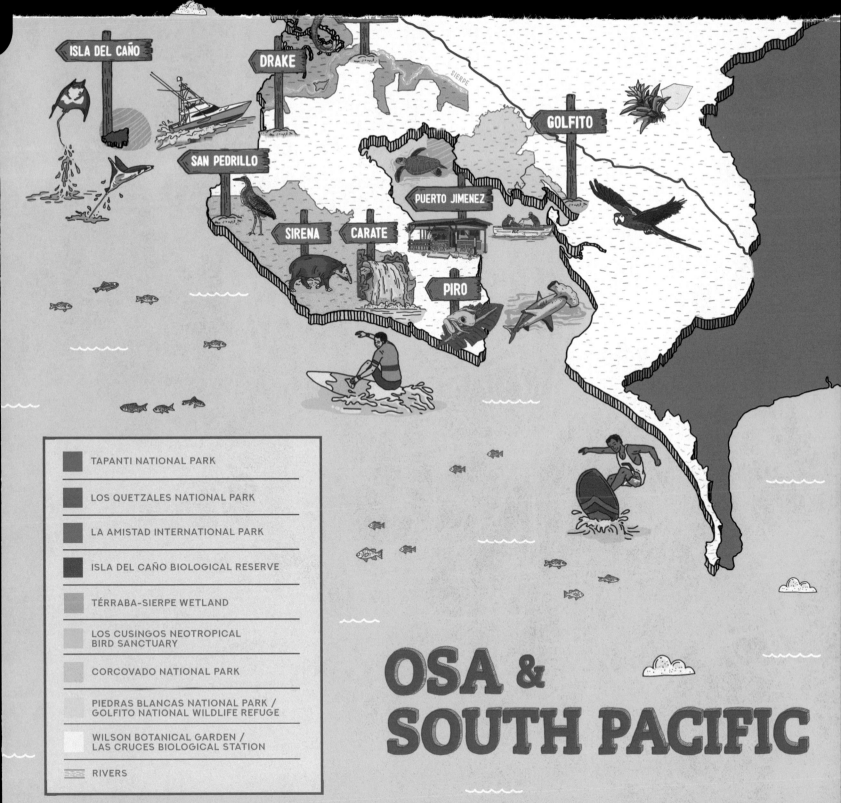

ISLA DEL CAÑO

DRAKE

SIERPE

GOLFITO

SAN PEDRILLO

PUERTO JIMENEZ

SIRENA

CARATE

PIRO

OSA &
SOUTH PACIFIC

TAPANTI NATIONAL PARK

LOS QUETZALES NATIONAL PARK

LA AMISTAD INTERNATIONAL PARK

ISLA DEL CAÑO BIOLOGICAL RESERVE

TÉRRABA-SIERPE WETLAND

LOS CUSINGOS NEOTROPICAL
BIRD SANCTUARY

CORCOVADO NATIONAL PARK

PIEDRAS BLANCAS NATIONAL PARK /
GOLFITO NATIONAL WILDLIFE REFUGE

WILSON BOTANICAL GARDEN /
LAS CRUCES BIOLOGICAL STATION

RIVERS

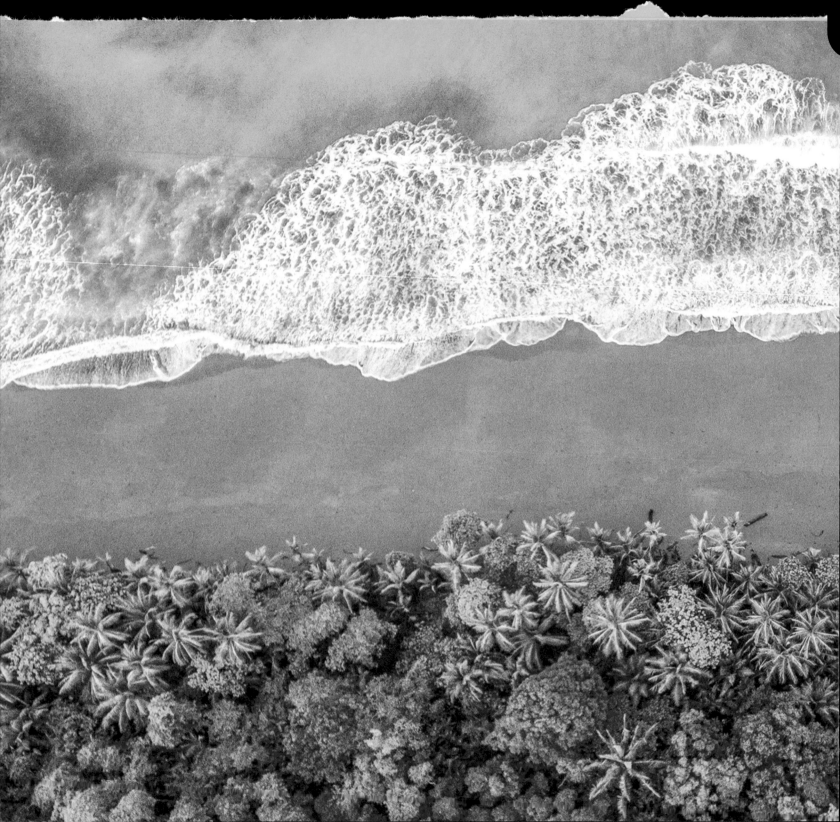

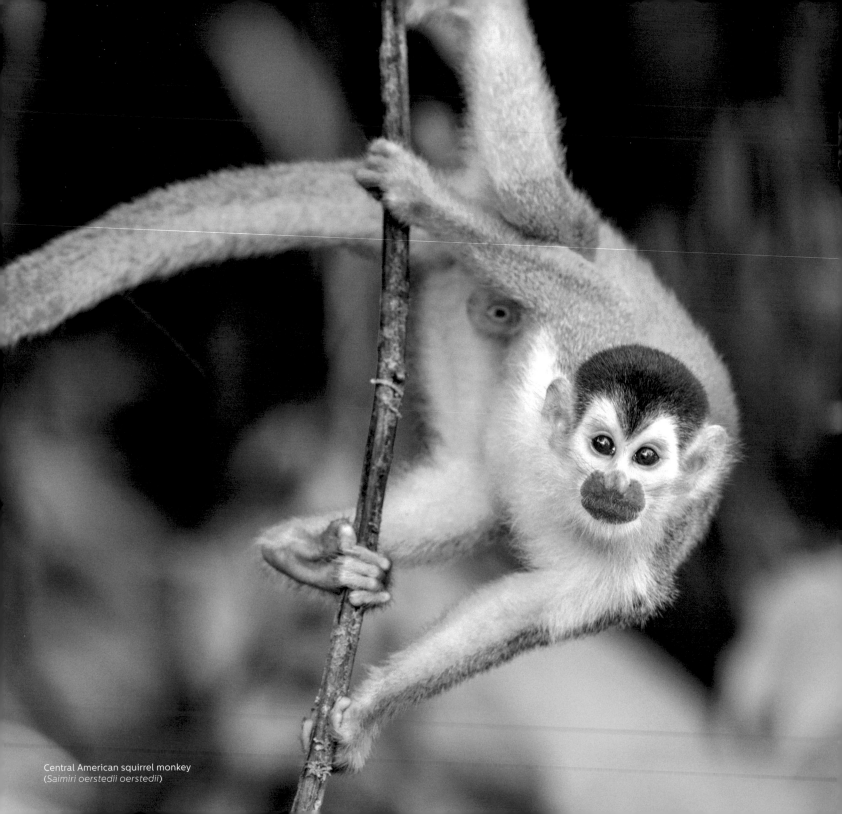

Central American squirrel monkey
(*Saimiri oerstedii oerstedii*)

The sun rises on a deserted beach on the Osa Peninsula, in southwestern Costa Rica, as the boat that brought us is buffeted by the waves. In this part of the country, nature rules. Indeed, just a few steps from the beach a troop of squirrel monkeys jumps from branch to branch, presumed masters of their tiny dominion. Surprised, we stop to watch them for a few minutes. The monkeys shake the branches and flip their leaves, searching for a morning snack of insects. We, entranced by the movement of these simians, begin to realize they are doing the opposite: ignoring us.

Initially we take this as an anomaly, but then it happens with other animals: a coati (*Nasua narica*) digs into a crab burrow without asking us for food, an anteater (*Tamandua mexicana*) calmly scrapes at the bark of a tree several yards above the ground, and a tapir (*Tapirus bairdii*), the chubby star of the Neotropics, allows us to approach her until we are only a few feet away as she dozes in a mudhole to escape the heat. She moves her ears, barely, but does not open her eyes. The area surrounding Sirena Biological Station, in Corcovado National Park, is one of the few places in the country where humans are, apparently, invisible.

Located in the southernmost part of the country, almost at the border with Panama, the Osa Peninsula and the waters of Golfo Dulce are a distant paradise.

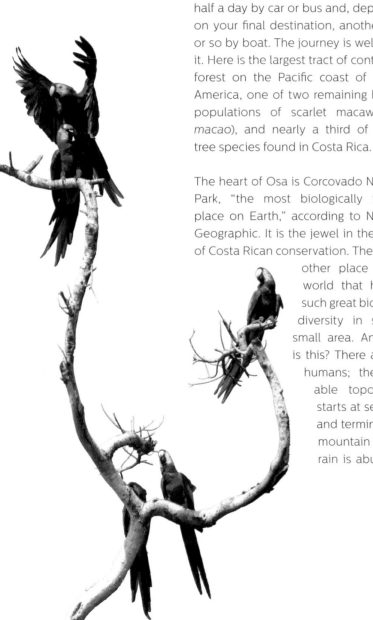

To get there from San José, you need half a day by car or bus and, depending on your final destination, another hour or so by boat. The journey is well worth it. Here is the largest tract of continuous forest on the Pacific coast of Central America, one of two remaining healthy populations of scarlet macaws (*Ara macao*), and nearly a third of all the tree species found in Costa Rica.

The heart of Osa is Corcovado National Park, "the most biologically intense place on Earth," according to National Geographic. It is the jewel in the crown of Costa Rican conservation. There is no other place in the world that harbors such great biological diversity in such a small area. And why is this? There are few humans; the variable topography starts at sea level and terminates at mountain peaks; rain is abundant, with more than 195 inches (5000 mm) per year; and there is a lot of food.

Osa lies today within boundaries mapped out by conservationists in the 1970s, protected wildlife areas that cover most of the peninsula. Corcovado, Golfo Dulce Forest Reserve, Piedras Blancas National Park, and a dozen other reserves protect nature that suffered several scares in the 20th century.

Between 1920 and 1930, the United Fruit Company bought nearly the entire northern half of the Osa to incorporate it into its banana empire, but after the purchase the company determined that the soils, topography, and inaccessible terrain were not suitable for banana production, and it quickly lost interest in the area. Almost three decades later, in 1957, the US conglomerate Osa Forestal bought the land and obtained a generous permit from the government to log the area with few restrictions, including in the Corcovado basin, which is now the heart of the national park that was named after it.

Although they began to till the ground and redraw map lines, Osa Forestal made little progress. On its lands were dozens of small settlements; in places like Rincón and Bahía Drake, farmers lived simple lives, tending a few acres of corn and rice, raising chickens, and hunting in the surrounding forest. For the conglomerate, these settlements stood in the way of their plan to cut millions of trees. Meanwhile, bureaucratic hurdles and legal disputes also helped keep the project in limbo. Ironically, as the rest of the country lost swaths of forest, Corcovado remained relatively untouched for nearly another decade.

But in the early 1970s, the Pan-American Highway brought the rest of the country closer to Osa and, with it, new threats to this paradise. When Osa Forestal accelerated plans to remove families from the area and begin wood production, scientists and conservationists in the region sought help from the nascent National Parks Service and its two leaders, Mario Boza and Álvaro Ugalde. Boza and Ugalde managed to convince then president Daniel Oduber to offer the company a deal. The government proposed exchanging roughly 37,000 acres (15,000 hectares) of barren land for around 34,500 acres (14,000 hectares) of luxuriant forest in Corcovado. Although this national park was created by executive decree in October 1975, it formally came into existence a year later, once the government had managed to relocate 100 families that were living in the park illegally and to remove most of the gold miners that were installed there.

From the perspective of conservationists, Corcovado has the bad luck of holding extensive gold deposits. For every environmentalist who seeks to protect these forests, there is a miner intent on laying open the earth. In 1985, an invasion of gold miners forced the park to close. Although the crisis was finally contained, the presence of gold prospectors in Osa is a recurring problem. Along with hunting and the extraction of wood, gold in Corcovado continues to pose one of the main risks for the park.

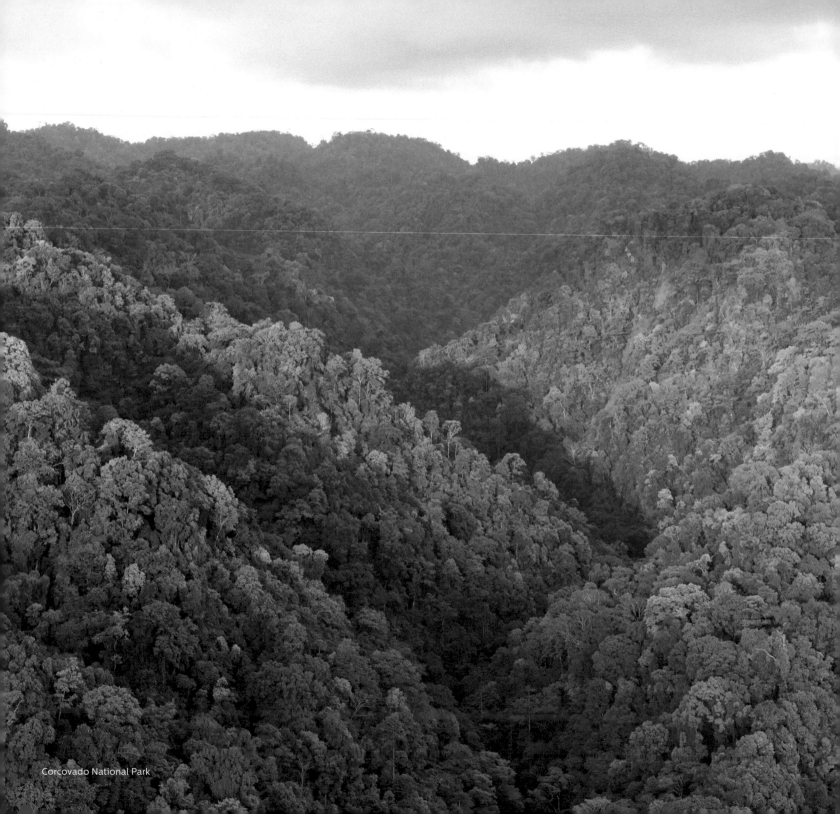

Corcovado National Park

Growing numbers of tourists come to view the wildlife. No other place in Costa Rica, indeed on the Central American isthmus, offers such ideal conditions for seeing mammals, including an abundance of tall trees with clear understory. Although even here jaguars (*Panthera onca*) are a rare sight, they sometimes come to the beach to break open the shells of sea turtles and feed on them. On Playa Sirena, tapirs come out from among the trees to bathe in the waves that reach the shore and groups of coatis run along the beach, headed who knows where.

Corcovado is one of the few places in Central America where virgin rainforest meets the sea. The northern "door" to the park is Drake Bay, a cove with a little town nestled in the forest. Boats filled with tourists depart from the cove in the mornings. It is named after the English captain, Francis Drake, who stopped here in 1579 while attempting to circumnavigate the world. Isla del Caño, one of the best diving spots in Costa Rica, is just 12 miles (20 km) from the bay. On the boat ride out and back, you are often accompanied by leaping dolphins. This spectacular biological reserve has a coral reef and usually clear waters that allow for viewing sharks, whales, and rays gliding serenely beneath the waves.

On the other side of the peninsula, another treasure awaits: Golfo Dulce, one of only three tropical "fjords" in the world. At the point where it connects to the sea, the gulf it is barely 200 feet (60 m) deep, while the deepest point in the gulf is over 650 feet (200 m) deep. These conditions result in waters so calm that they receive all kinds of visitors, including whale sharks, the largest fish in the world.

On land, the most valuable form of gold is colored green, while here it is a lovely shade of blue. Nearly 23% of the coastal-marine diversity of the Costa Rican Pacific can be found here, and this is one of the most important shark sanctuaries in the eastern region of the Pacific. Female sharks congregate in the coastal wetland that forms near the mouth of Rio Coto, east of the gulf, and their

young grow there, especially those of the hammerhead shark (*Sphyrna mokarran*), which benefits from the turbid and nutrient-rich waters that provide both refuge and food.

This fecund, dense region remains largely unstudied, unknown. Although scientists like Henri Pittier have been coming here since the late 19th century to draw birds and collect plants, the Osa occasions more questions than answers. Only in the 1990s did biologists begin to study the waters of the gulf. Many sections of the park, including Corcovado Lake and its cloud forest, remain largely unstudied. How many insects hidden in the leaf litter await classification? How many species of vine climbing through the canopy have yet to be studied? In an age of information overload, the Osa presents us with an unfamiliar spectacle, an uncharted land.

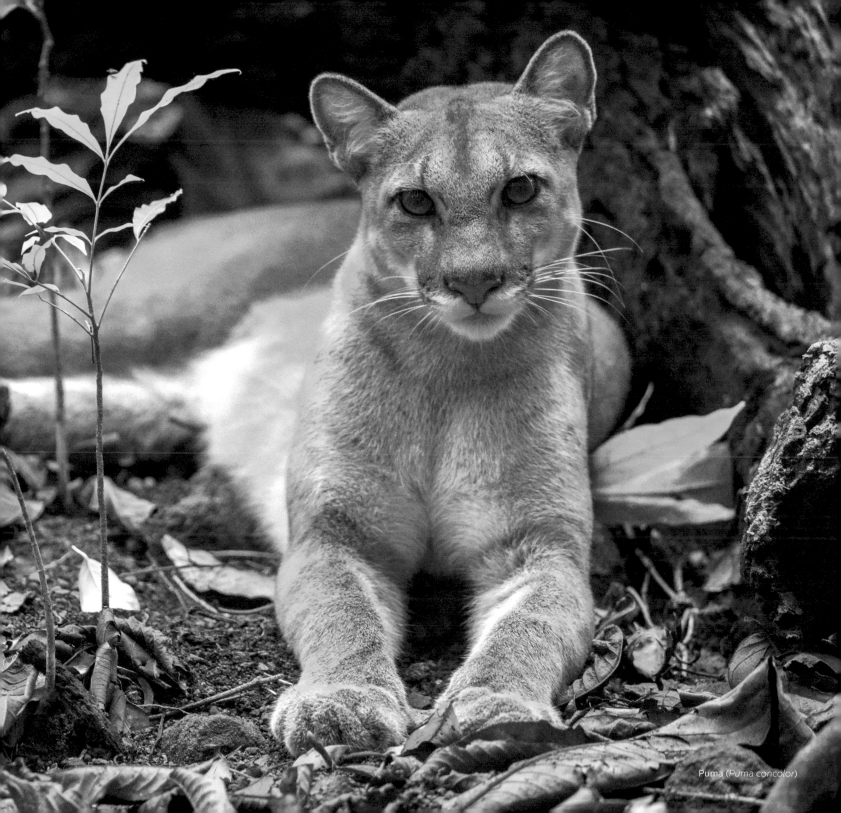

Puma (*Puma concolor*)

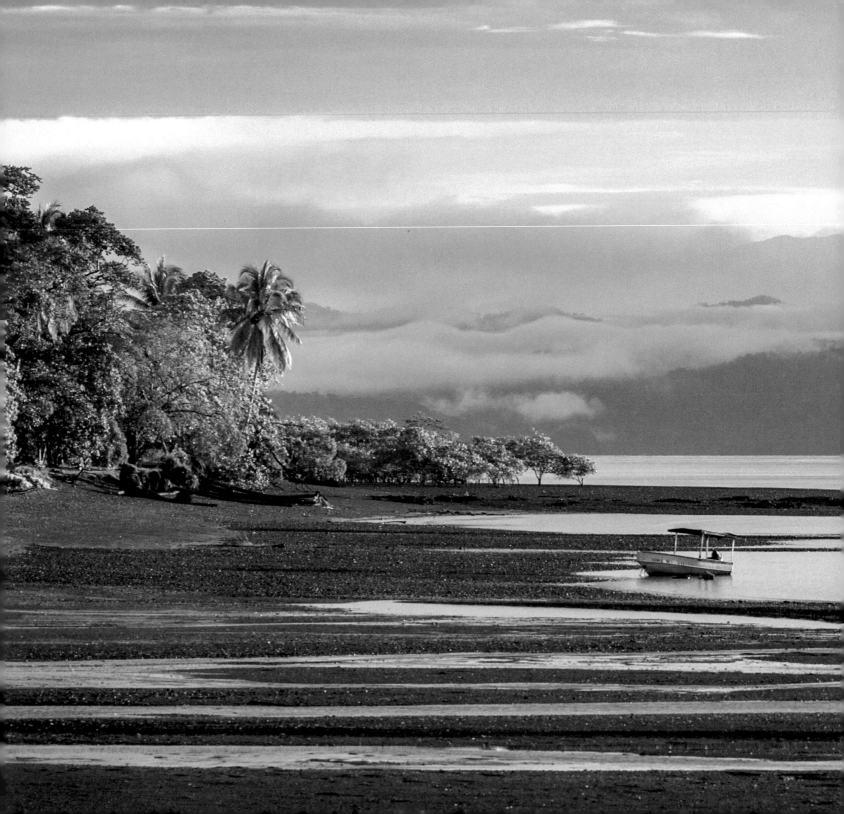

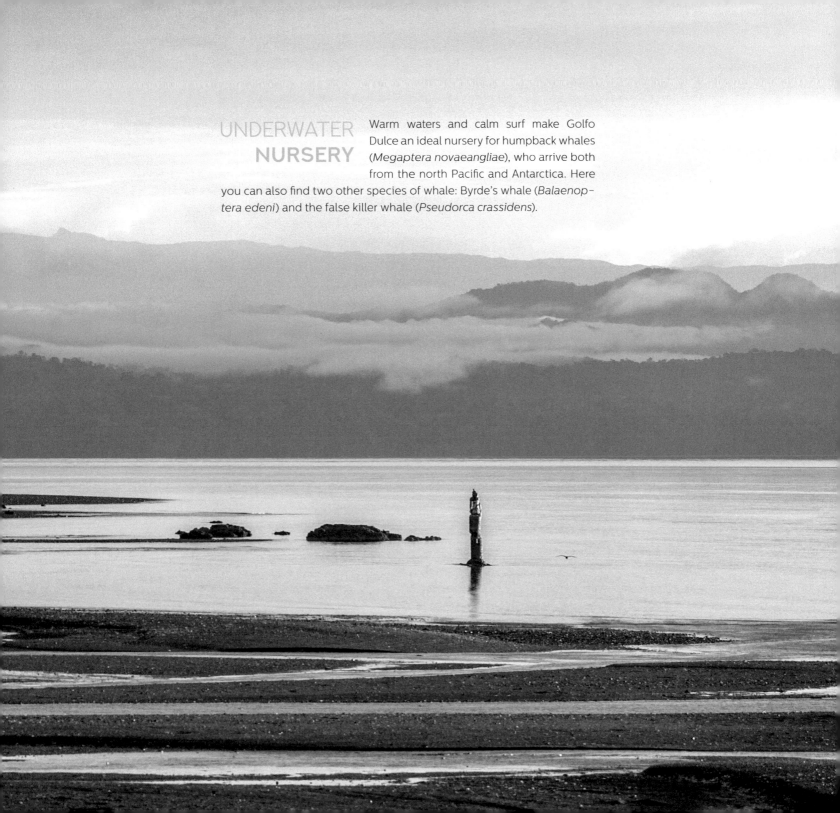

UNDERWATER
NURSERY

Warm waters and calm surf make Golfo Dulce an ideal nursery for humpback whales (*Megaptera novaeangliae*), who arrive both from the north Pacific and Antarctica. Here you can also find two other species of whale: Byrde's whale (*Balaenoptera edeni*) and the false killer whale (*Pseudorca crassidens*).

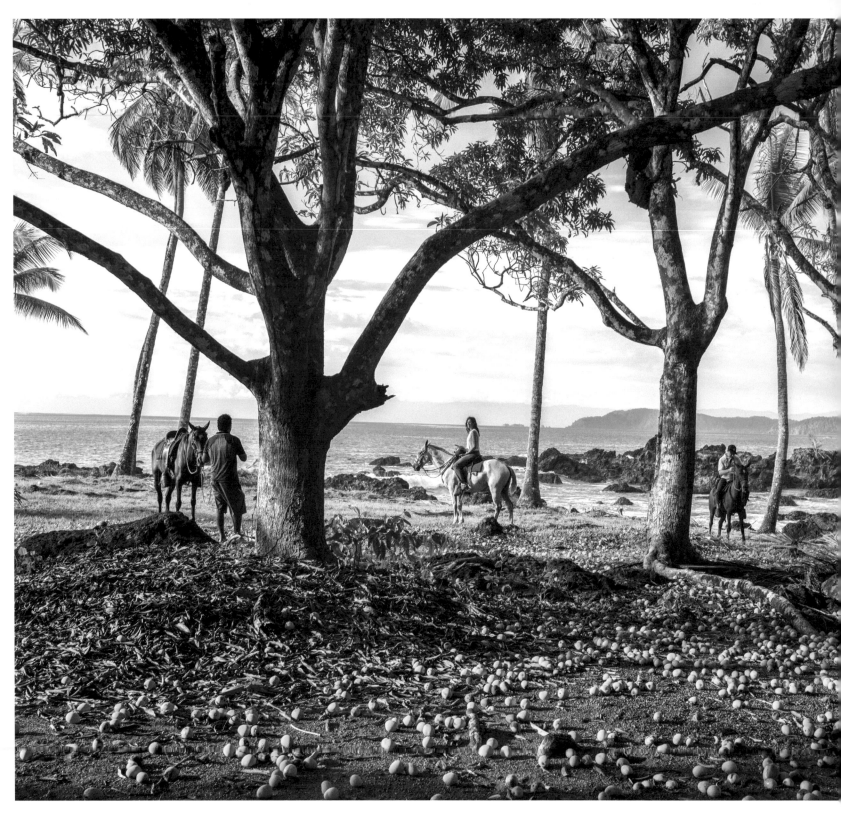

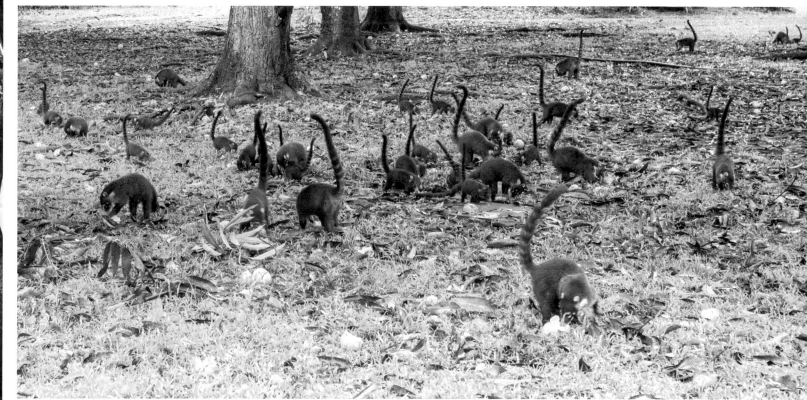

These mango trees are a legacy of failed attempts to farm on the Osa Peninsula. Even with the settlers long gone, four or five months each year the abundant crop continues to attract all types of animals, like these coatis (*Nasua narica*), who come to sweeten their palette.

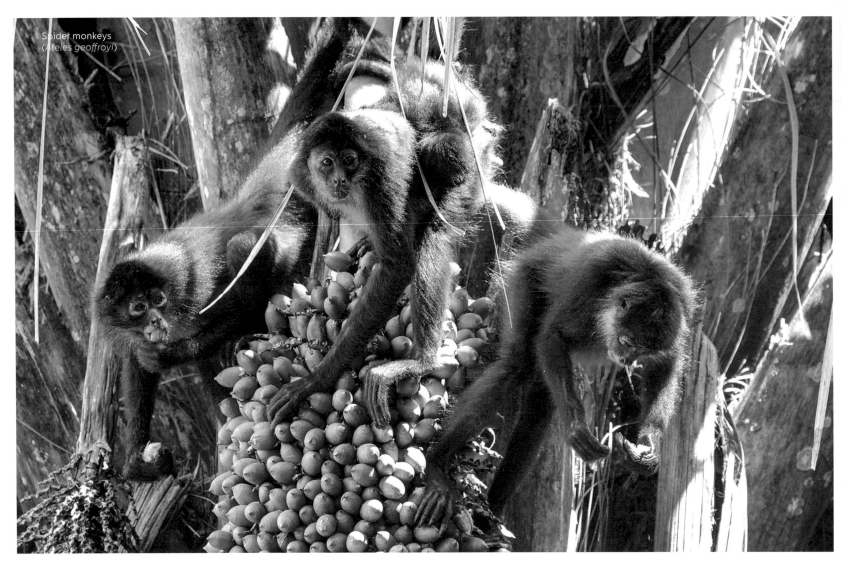

Spider monkeys
(*Ateles geoffroyi*)

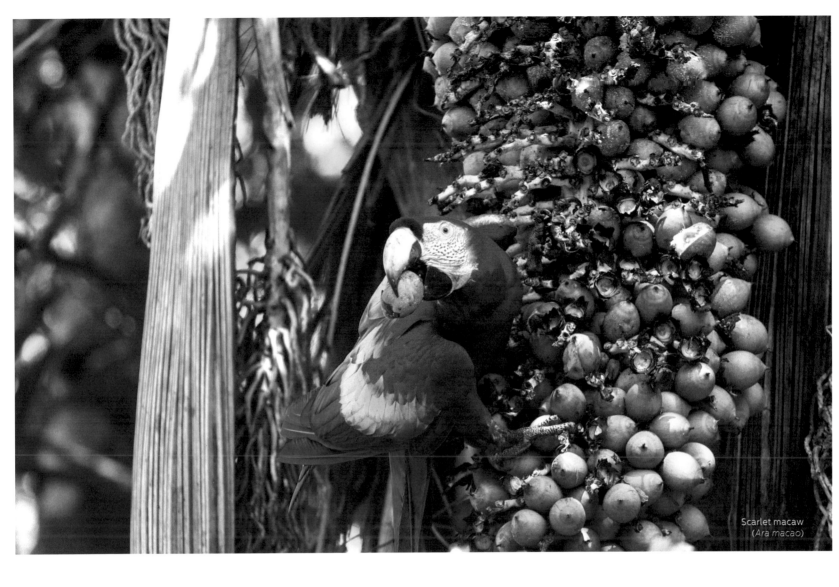

Scarlet macaw
(*Ara macao*)

The Osa is filled with an abundance and diversity of fauna in part because of the ample supply of food. Torrential rains, high temperatures, and a variety of elevations and ecosystems result in plants and trees of all kinds, laden down with fruits and seeds.

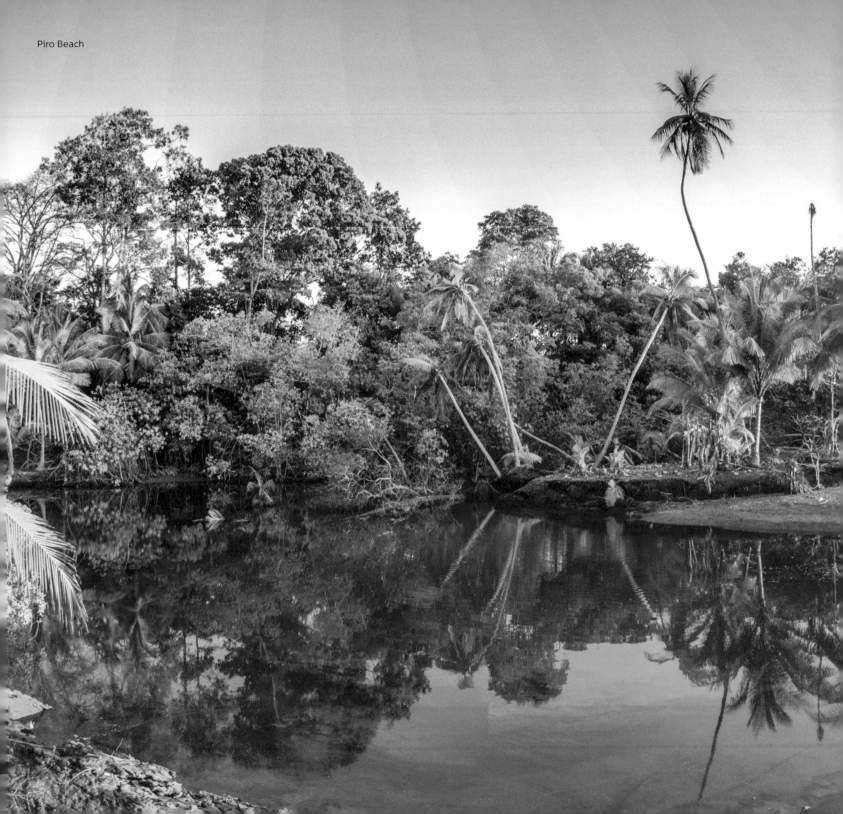

Piro Beach

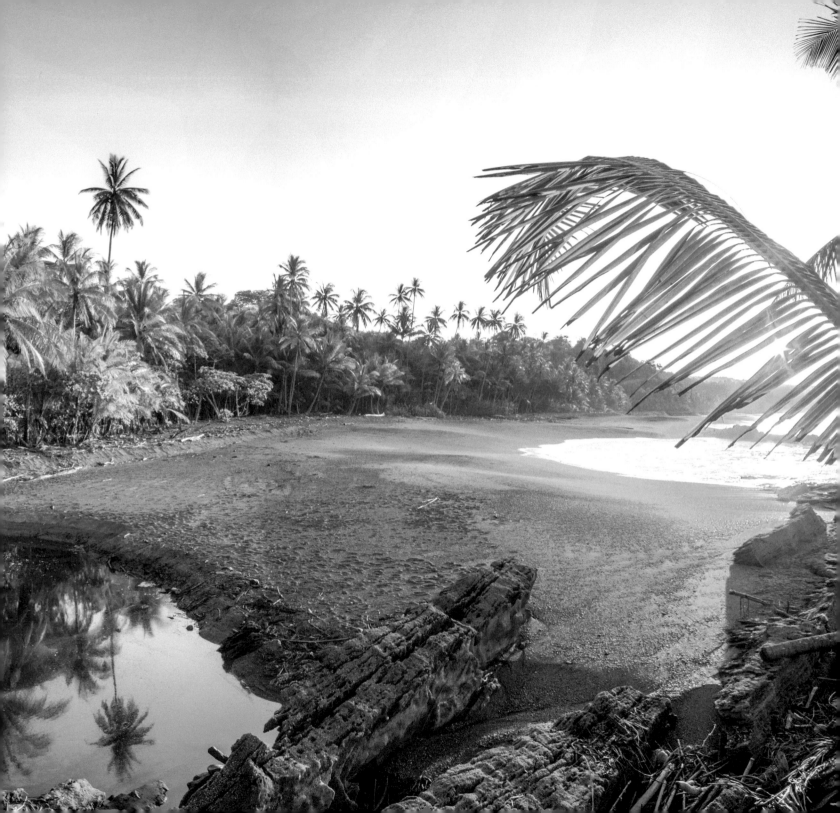

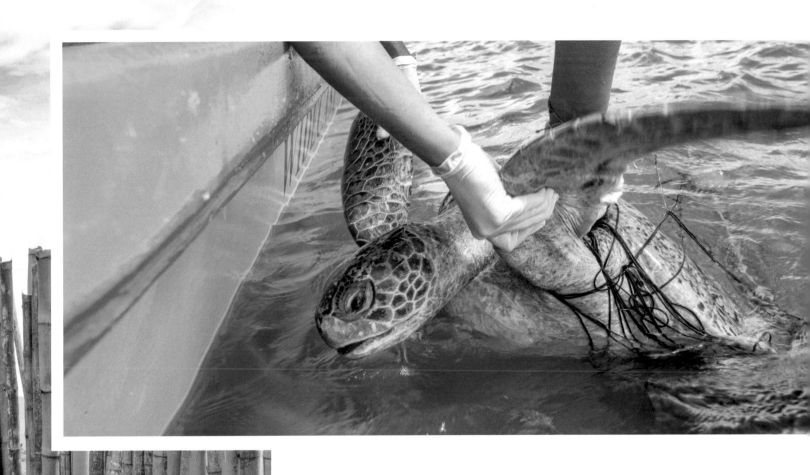

Four of the five species of sea turtle that visit the country nest in Osa. Organizations like Osa Conservation and Latin American Sea Turtles receive volunteers who patrol the beaches and build hatcheries to protect the turtle eggs, helping to ensure a higher survival rate for the hatchlings.

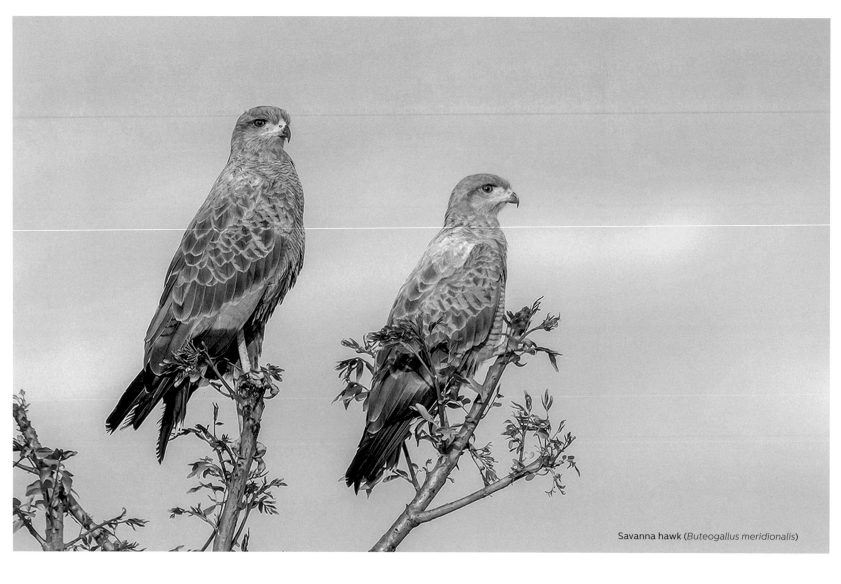

Savanna hawk (*Buteogallus meridionalis*)

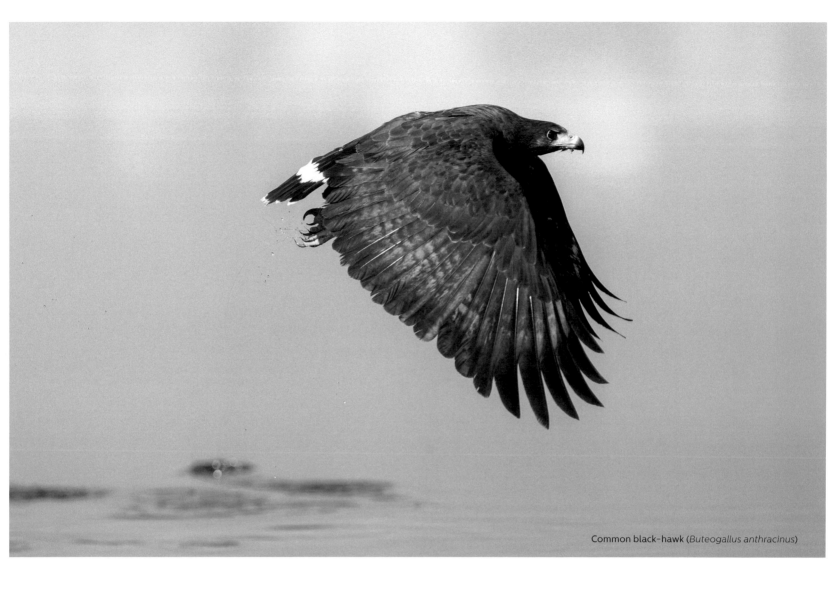
Common black-hawk (*Buteogallus anthracinus*)

All birds in the genus *Buteogallus* occur exclusively in the Neotropics. To avoid competition, each has adapted to a particular geographic range, determined by the existing habitats. The common black-hawk, a familiar sight in Costa Rica, extends from southern United States to Peru. The much rarer savanna hawk had not been seen farther north than Panama until 2008.

HIGH IN THE
CANOPY

In the tall reaches of the trees on the Osa, you can often spot the spectacular scarlet macaw. The canopy is also home to the white-faced, spider, squirrel, and howler monkeys. This is one of the few places in the country where you can see all four species, and do so easily.

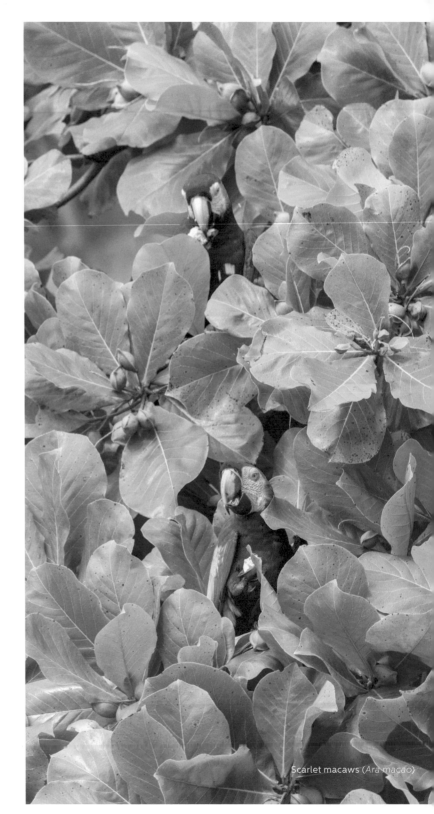

Scarlet macaws (*Ara macao*)

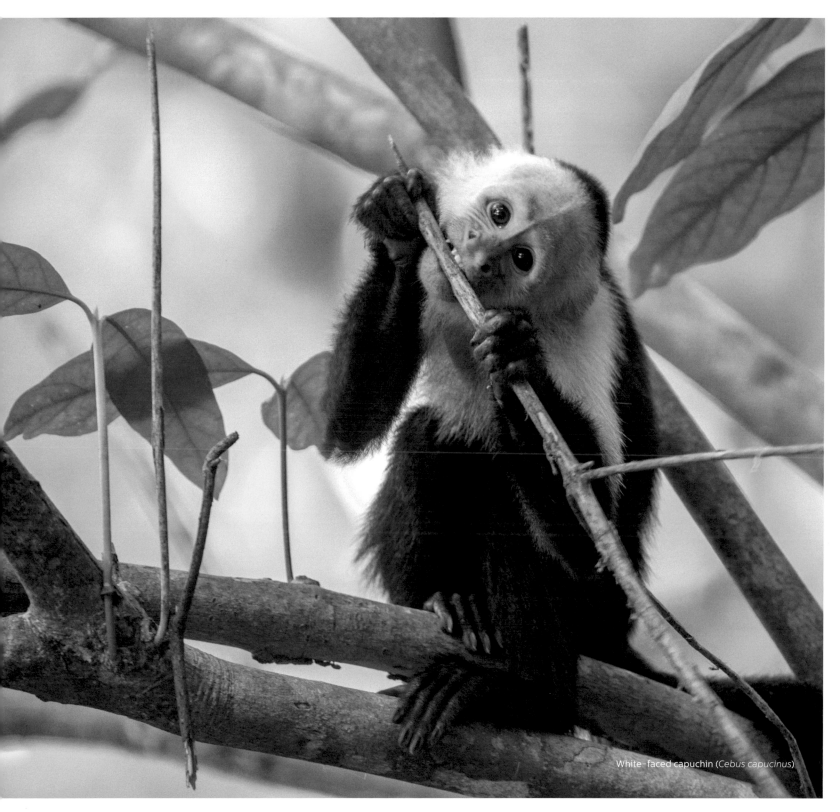

White-faced capuchin (*Cebus capucinus*)

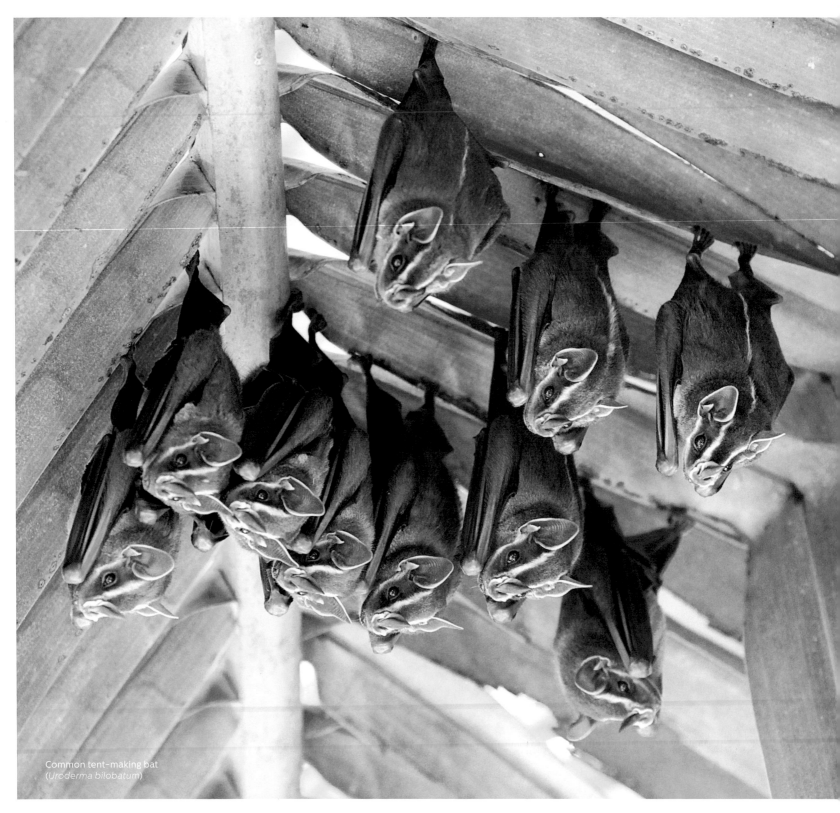

Common tent-making bat
(*Uroderma bilobatum*)

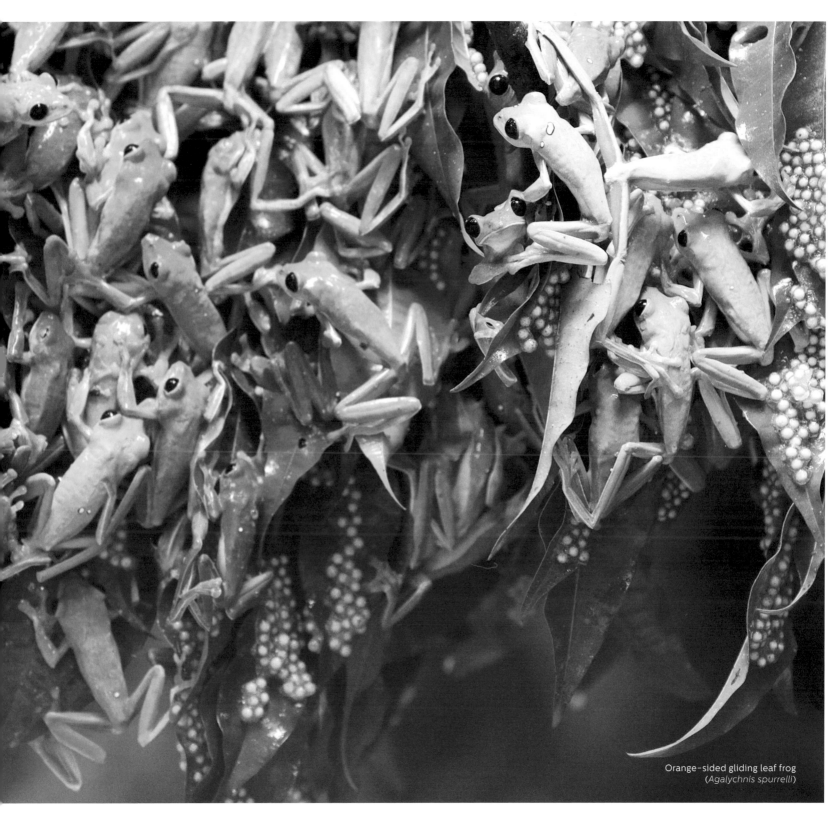

Orange-sided gliding leaf frog
(*Agalychnis spurrelli*)

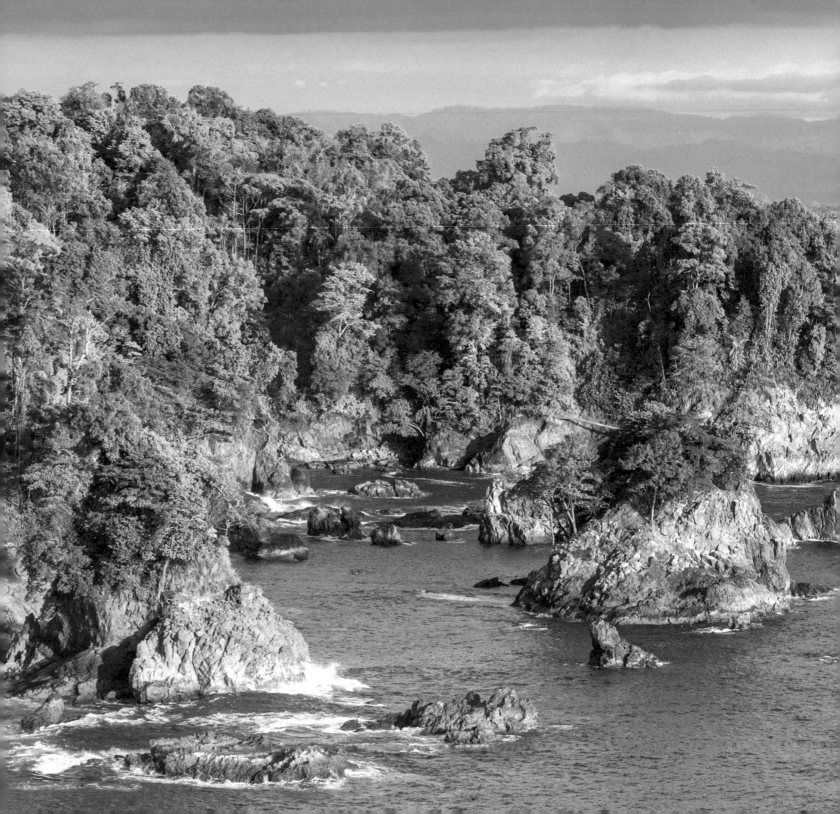

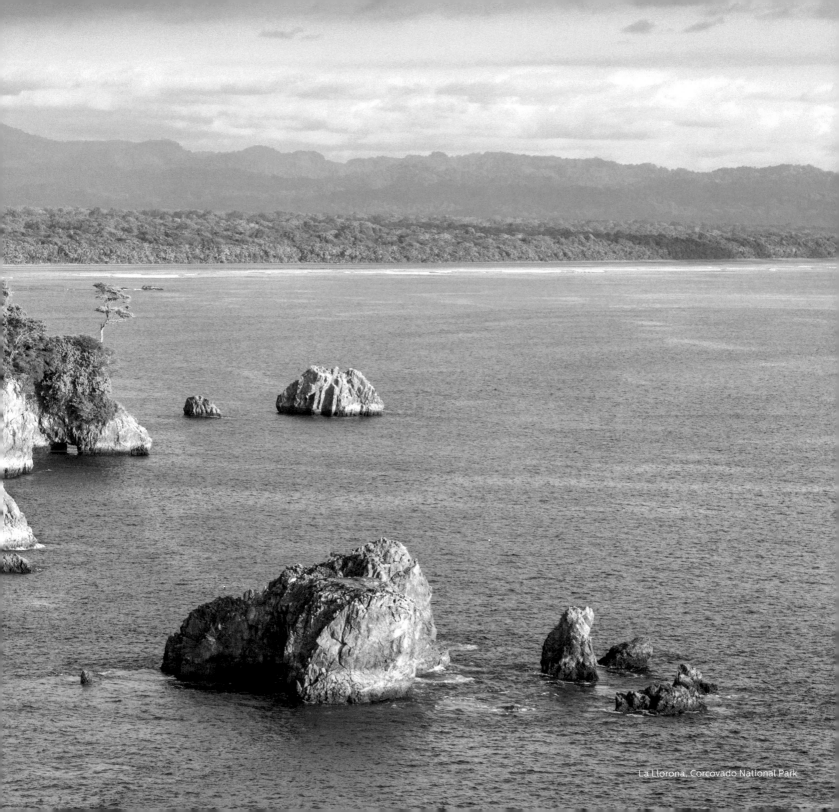

La Llorona, Corcovado National Park

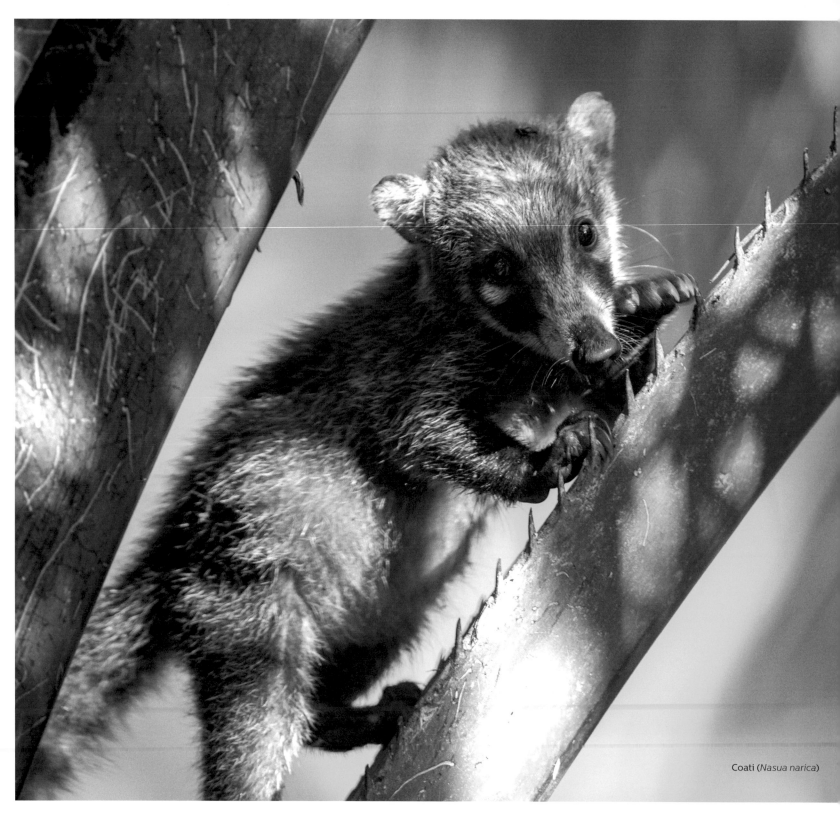

Coati (*Nasua narica*)

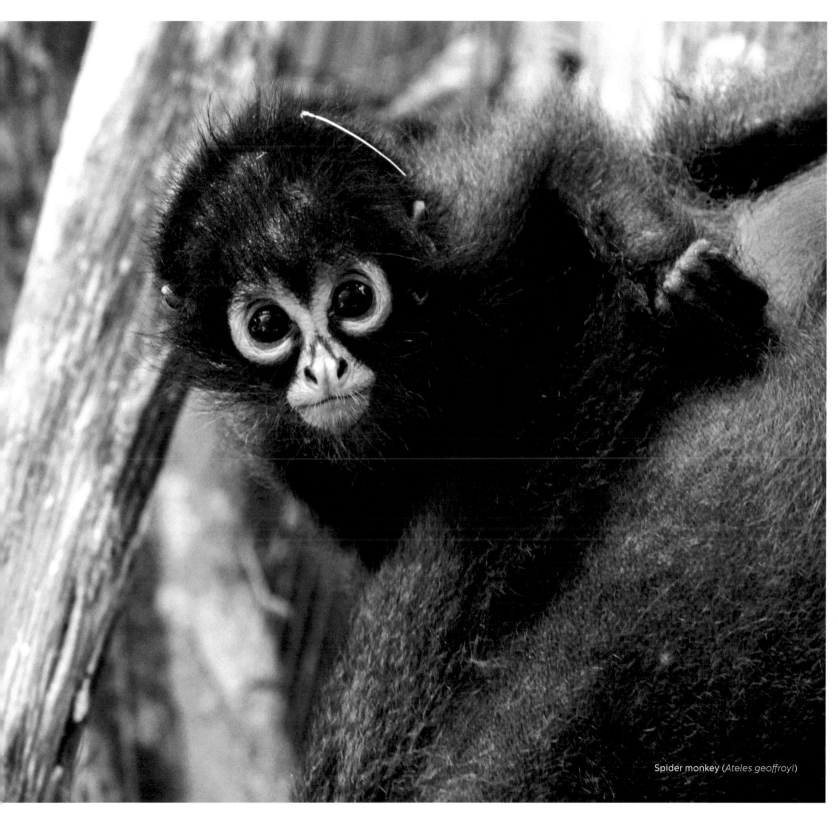

Spider monkey (*Ateles geoffroyi*)

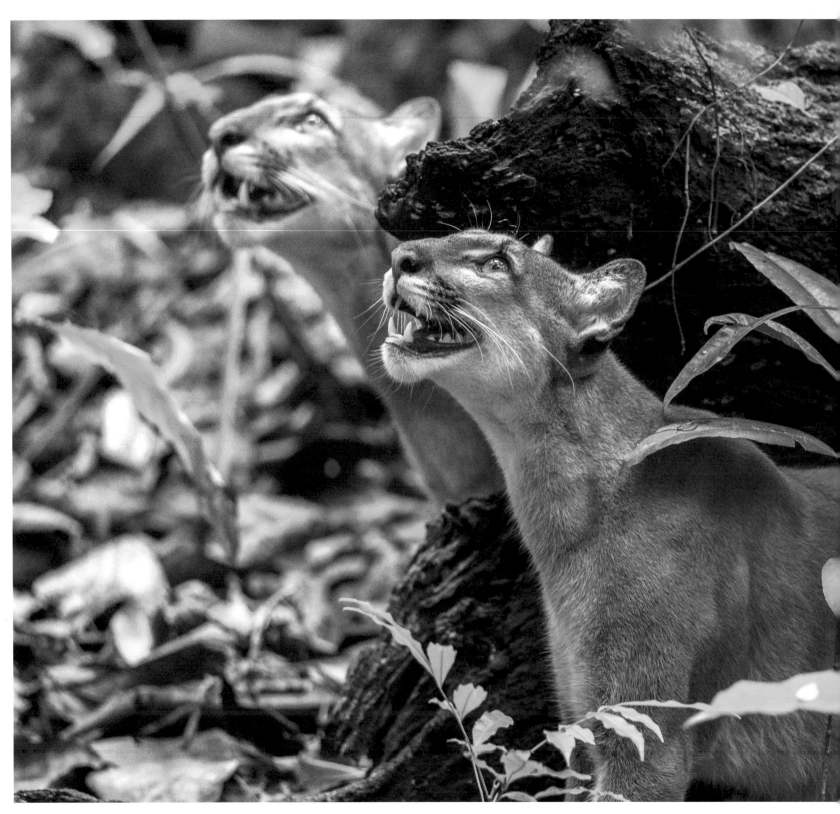

A NEW
KING

The jaguars in Corcovado depend nutritionally on white-lipped peccary (*Tayassu pecari*), because, at nearly 90 lbs (40 kg), they are the best source of food for a feline this large and active. As the populations of peccaries, and therefore of jaguars, have decreased due to illegal hunting, smaller carnivores like pumas (*Puma concolor*), pictured here, have begun to multiply and dominate the forests of Osa.

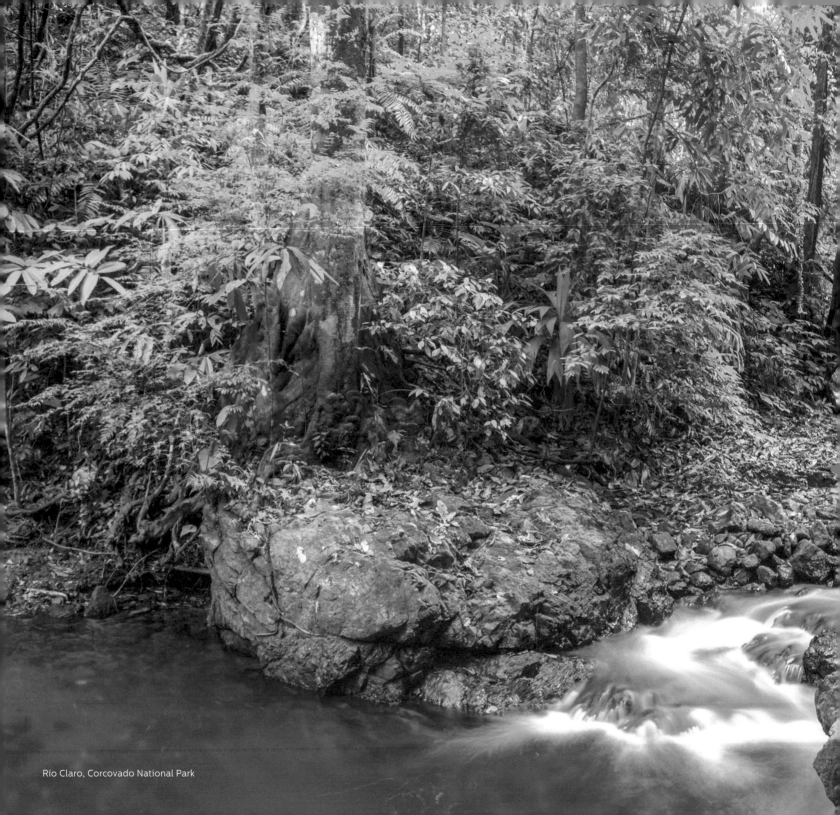

Río Claro, Corcovado National Park

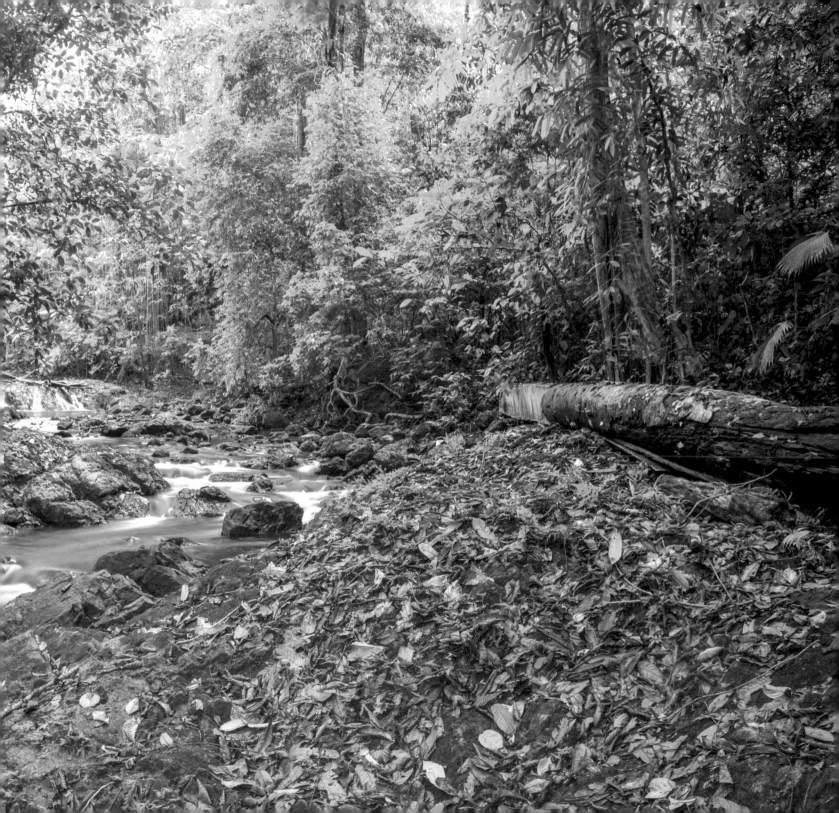

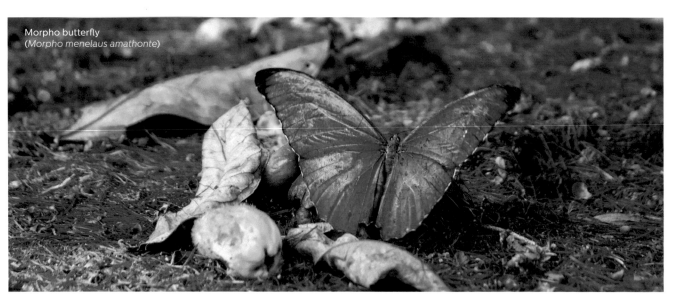

Morpho butterfly
(*Morpho menelaus amathonte*)

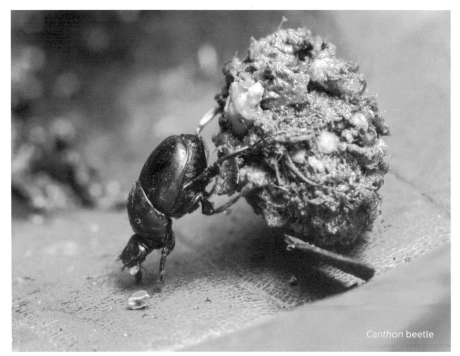

Canthon beetle

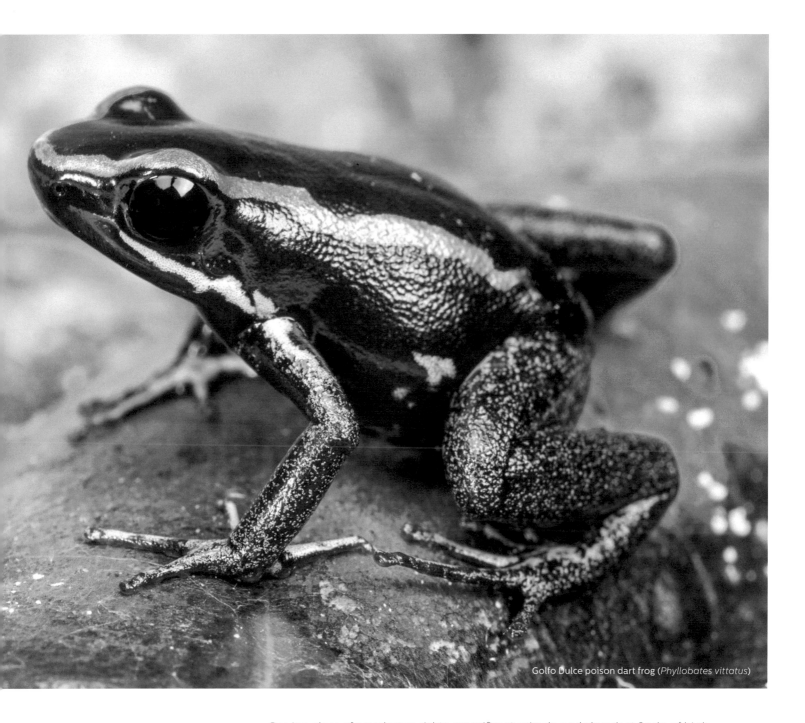

Golfo Dulce poison dart frog (*Phyllobates vittatus*)

Osa is a place of wonderous sights, magnificent animals, and abundant flocks of birds ...
but one mustn't forget to peak into even its smallest crevices, where fascinating things also occur.

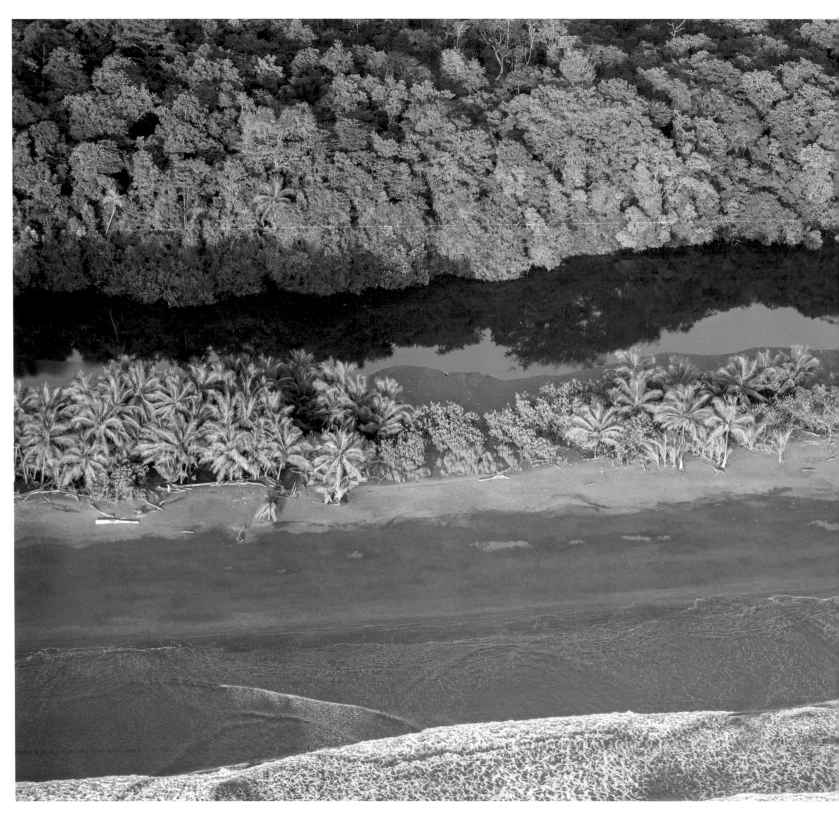

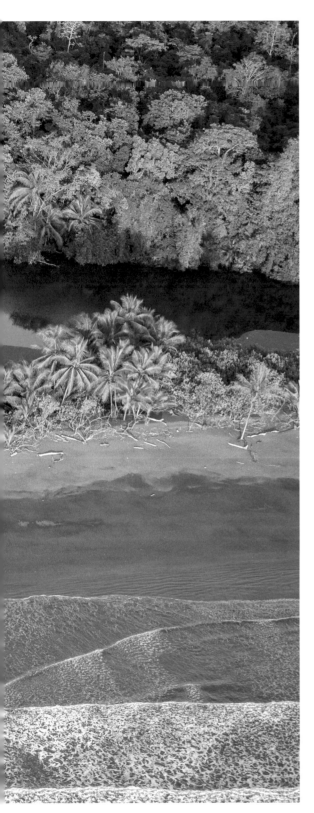

A MIGHTY
RIVER

Rio Sirena flows from Corcovado Lake, in the heart of the park, and snakes lazily to the Pacific coast. On its way, it lends its name to both the guard station at the park and the beach where visiting tourists disembark when they arrive. The mouth of this river is famous for sightings of tapirs bathing in the ocean and, at high tide, the outline of a bull shark swimming through the sea foam.

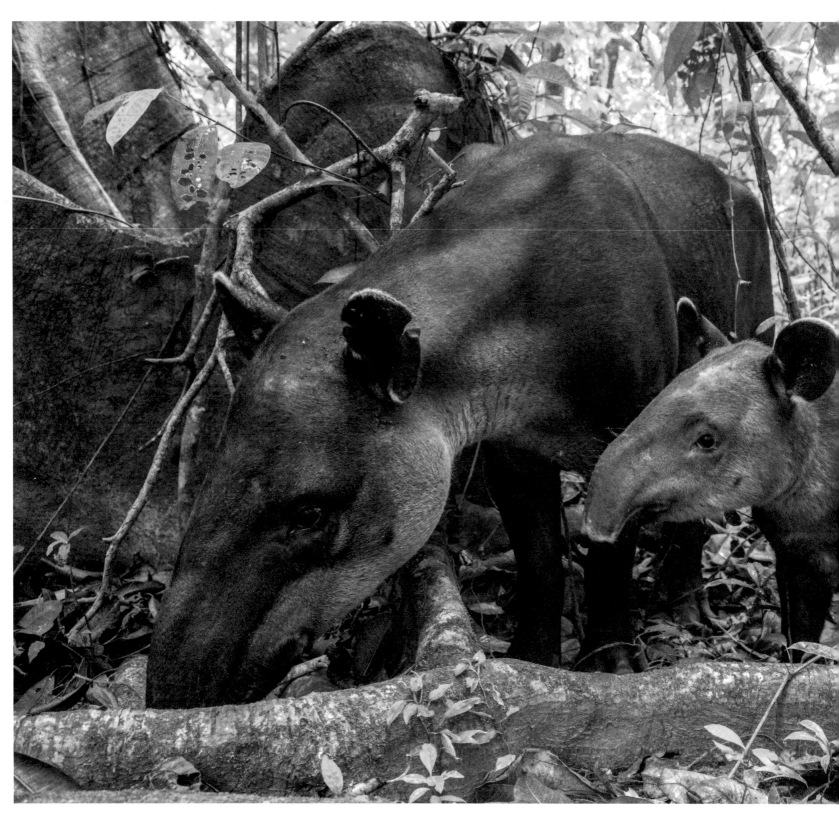

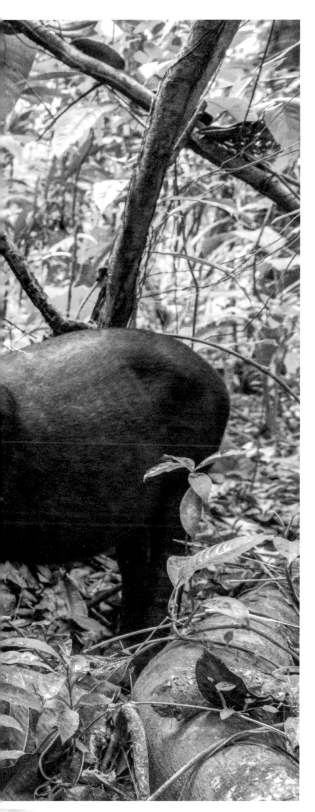

SOCIAL LIFE

The tapirs (*Tapirus bairdii*) of Playa Sirena have been interacting with humans for so long that they have forgotten their sense of fear. In other parts of the country, they hide quickly when they note the presence of humans, but not here. In this corner of Corcovado National Park, away from hunting zones, the relationship is so confiding that this mother can wander freely without fearing for her calf.

Playa La Llorona, Corcovado National Park

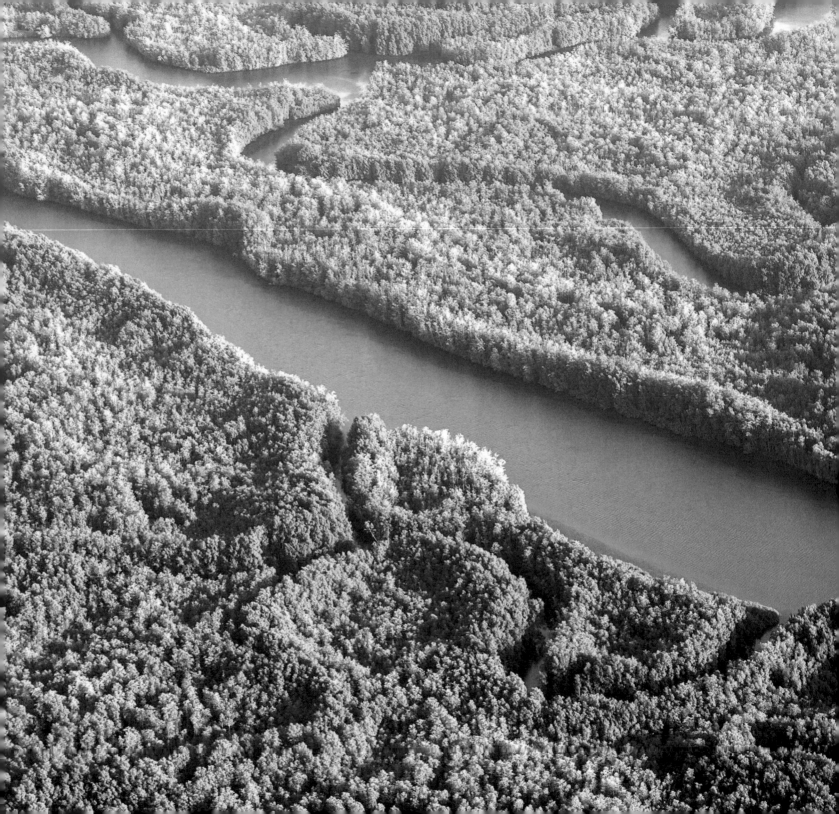

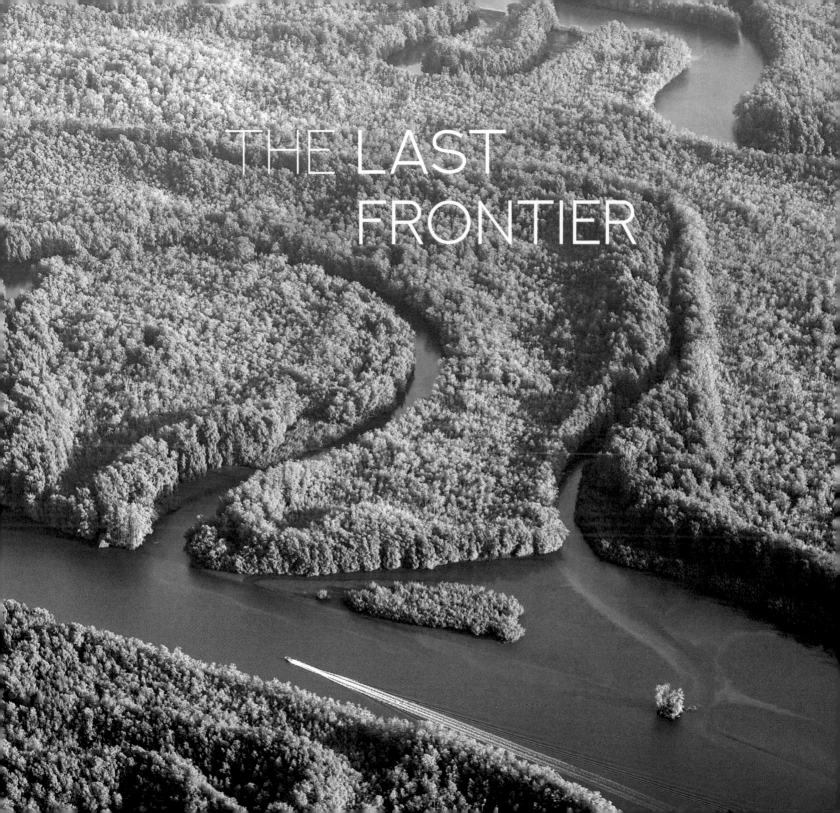

THE LAST FRONTIER

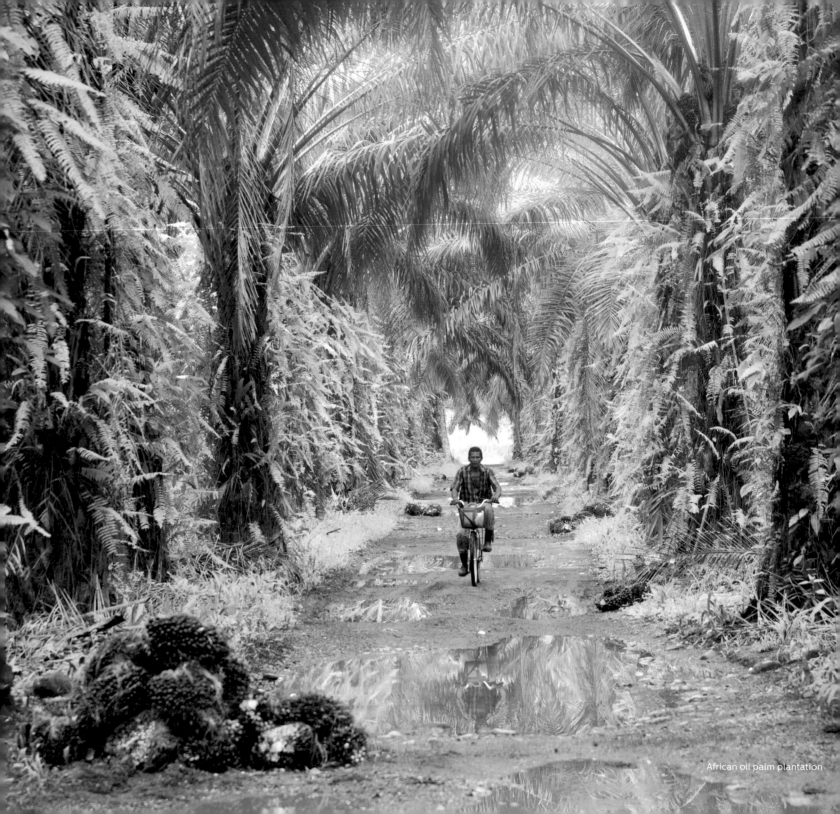

African oil palm plantation

In southern Costa Rica, between the hidden recesses of Corcovado and the majestic Talamanca Mountains, lies a land that defies easy characterization. Many places in the country are famous for obvious reasons. The cloud forests of Monteverde, the beaches of the North Pacific, and the hot springs of Arenal Volcano, for example, are all beautiful, if in distinct ways. But in this region, say in Punta Burica or the wetlands at the mouth of the Río Sierpe, the charm of the place does not readily present itself on first contact.

And, indeed, the traces of 20th century monoculture are visible almost everywhere. One longs for the forests of just one hundred years ago in places that today show the scars of banana production. Yet life abounds here, still. This is the site of the largest remaining wetland in the country, over which fly migratory birds seeking refuge from the boreal winter. And half a dozen indigenous communities live here. This is a land of mangroves and stone spheres that present a deep archeological mystery. These plains, irrigated by the Térraba, Sierpe, and Coto rivers, are, in a sense, the threshold to the south.

At first glance, the region seems to be entirely given over to agriculture. Rows of tall, bushy-haired palm trees follow one after another, like an army of tousle-haired youth. In spots, the monotonous landscape is broken up by a farmhouse, a bus stop where an old man waits with a bunch of plantains on his shoulder, a sign letting visitors know that they are about to arrive at farms Finca 6, Finca 10, and Finca 12. Occasionally, there is a soccer field. But eons ago, this was the site of one of the most important biological events in the Americas.

When the Isthmus of Panama formed several million years ago, these plains became a land bridge between North and South America. In what we call the Great American Interchange, species from the north migrated south and those in the south migrated north. Today, locally, this region connects Osa and Talamanca, two of the most important ecosystems in the country, thus helping preserve genetic diversity in the region.

One source of so much fecundity is the Térraba River, the longest in the country. Its tributaries collect the water flowing down from the Talamanca Mountain Range, forming a nearly 2000-square-mile (5000-km²) watershed. The Boruca indigenous people travel down the river today, just as they did five centuries ago, relying for protection on the deity Div Sújcral, the "Owner of the River." This is one of several indigenous communities that still live between the foothills of the mountain range and the coast. The river was their trade route and a couple of times each year their boats would go down to the coast to collect sea snails from which they extracted purple dye to produce fabrics that were highly valued by them.

Five centuries ago, the people of this region first saw Europeans when they encountered the Spaniard Gil González Dávila as he marched north with one hundred Christians, in search of gold and glory.

In the Boruca and Rey Curré indigenous territories, this clash is remembered each year in the *Juego de los Diablitos*, one of the most notable traditional festivals of the indigenous cultures in the country. Community members make masks from balsa wood and, dressed as devils, fight "the Spaniard," represented by someone wearing a bull mask. During

four days of festivities, houses open their doors and families give food to passersby.

Some words were adopted by the first European expedition, whose members used the names of the local chiefs to name the settlements: Osa, Burica, Coto, Borucac, and others. Although the names survive, the communities that Gil González Dávila encountered were not as fortunate. Many groups were extirpated and others, like the Boruca and Quepo, were forced to work as slaves herding mules, the most important commercial activity of the early colonial period.

At that time, the Spaniards' fear of pirates navigating the Pacific waters led them to create a terrestrial commercial route along the coast connecting Nicoya to Panama, which they named, without much fanfare, the Mule Trail.

Around 1706, the Spaniards lost interest in the region when the Portobelo trading fairs in Panama ceased, and as a result the local economy declined. One can picture the sense of isolation experienced by the people here in the first years after independence; they were separated from the capital cities of Cartago and San José by the tallest mountain range in the country, living in a land of rivers and mangroves that made travel even within the region difficult. The one point of contact was through trading boats, some barely seaworthy, which would travel back and forth between Puntarenas in the north and settlements like El Pozo (present day Ciudad Cortés), near the mouth of the Térraba River.

The economic fortunes of the area changed with the arrival of blond engineers weighted down with instruments used to study soil and measure out plots of land. They were employees of the United Fruit Company, which transplanted its operation from the Caribbean to the Pacific side of the country in the late 1930s. Its immense territory spanned from the center of the Pacific coast of the country to the border with Panama.

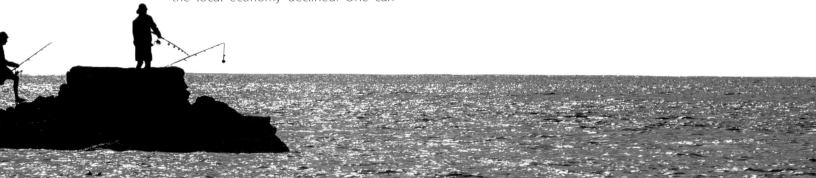

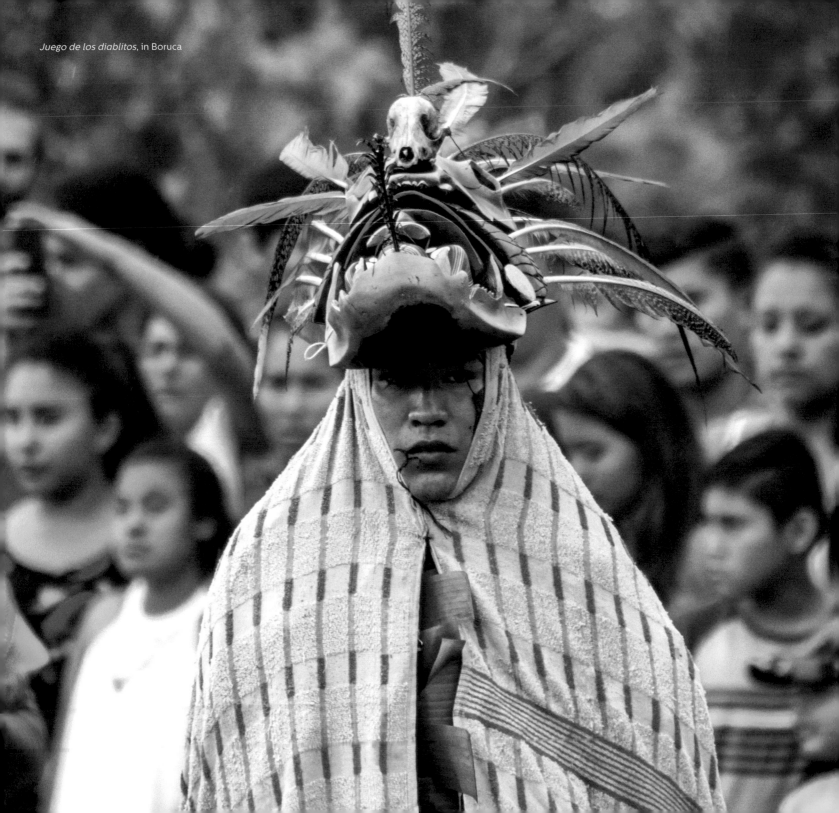

Juego de los diablitos, in Boruca

La Yunai, as the United Fruit Company was popularly known in Costa Rica, had the money and political backing to essentially create a country within the country, often making decisions heedless of the will of municipal governments and shaping the landscape as it pleased. While the Spaniard González Dávila borrowed the names of indigenous chiefs to create place names, the banana company didn't bother—they numbered the farms, and today towns still have names like Finca 9, Finca 63, and Coto 47.

The machinery of United Fruit unearthed archaeological treasures that had long laid hidden. In 1939, stone spheres buried in the Diquís Delta were lifted from sediment deposited by the river over centuries. Modern records show over 500 stone spheres, objects left behind by a civilization that inhabited the delta before the Spaniards arrived. More than 50 of these spheres weigh more than 1 ton, with the largest, 8.5 feet (2.57 m) in diameter, weighing over 20 tons.

Although most of the spheres have been removed from their original sites, some have not, including those at Finca 6, one of four places declared a World Heritage Site in 2014. Here, three spheres, almost completely buried, are arranged to form a line; twice a year, when the sun is at its zenith over Costa Rica, the line points exactly to the spot where the sun will rise. Who made them? How were they moved? What was their purpose? Exact knowledge will perhaps forever elude us, though theories abound, including wacky speculation about visitors from other planets.

In their natural "habitat," the spheres coexist with one of the most biologically diverse places in the country, the Diquís Delta. Nearly 1000 species of plants and a quarter of all bird species in the country thrive here; amazingly, there are 26 endemic species in this tiny region. The delta is formed by the confluence of the Térraba and Sierpe rivers, whose meandering branches bring life to the Térraba-Sierpe National Wetland, the largest and most stable in the country.

A journey through the palm plantations on the road to the town of Sierpe might suggest that the encroaching fields will end up suffocating the wetlands. But within the wetlands themselves, amid islets and mangroves, the sight of a heron suggests another possible future. The stately bird has inhabited the region for eons. In the heart of the mangrove, one barely notices the noise from farm machinery. The only sound is that of the waves lapping against the boat.

In the South Pacific, the "asphalt" has # BLUE **STREETS**
a blueish sheen. Without paved roads,
rivers like the Sierpe are the highways that connect towns, protected
areas, and docks. This was the last region to be "connected" to the rest
of the country.

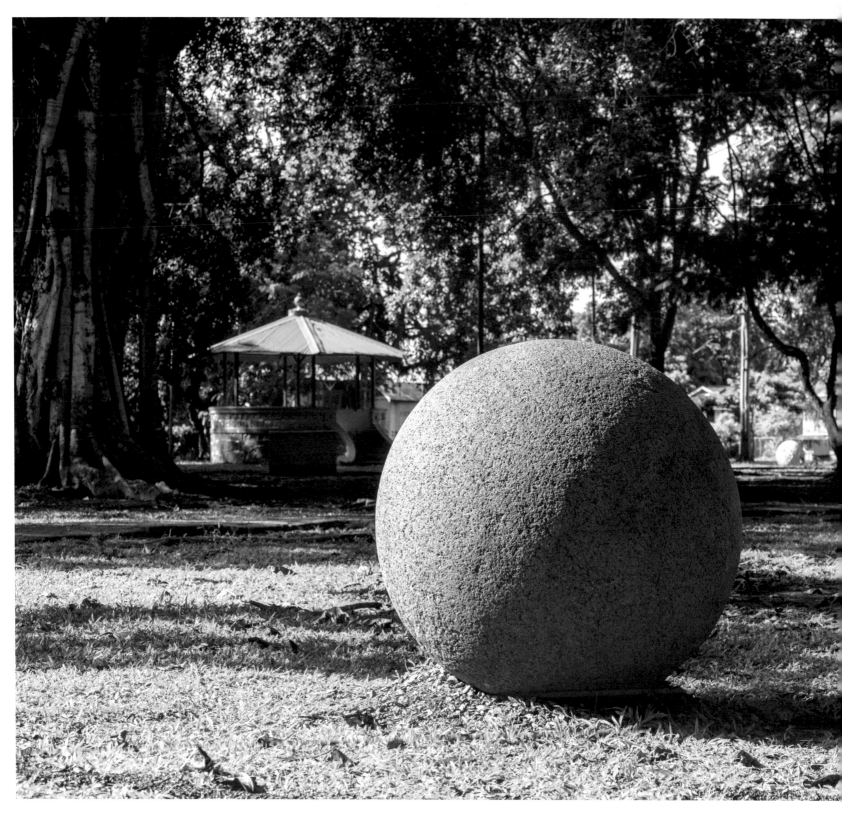

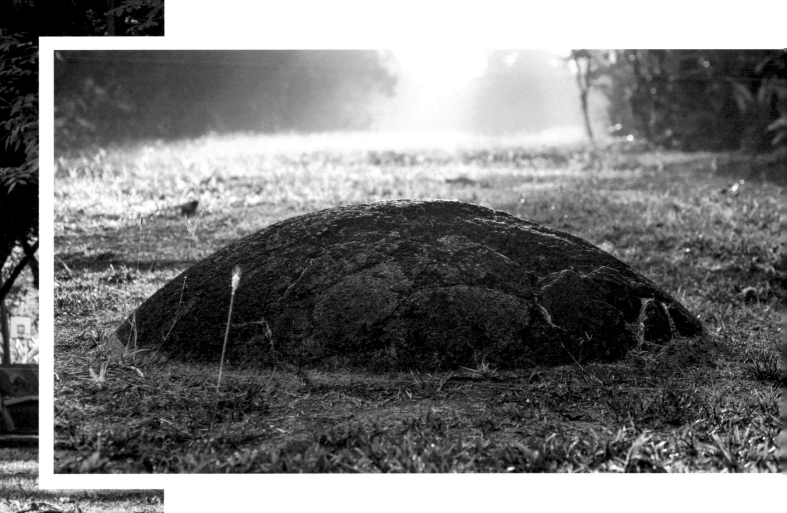

Although there are over 500 petrospheres in the country, we still understand very little about these mementoes left by the civilization that inhabited the southern region of the country between 400 A.D. and the arrival of the Spaniards. The fact that many have been moved from their original locations makes it more difficult to decipher this conundrum. However, at Finca 6, archeologists discovered a first clue; there are three partly buried spheres there in their original locations, and when the sun is at its zenith over Costa Rica, you can see that they are aligned with the point where the sun rises.

DEVILS MAY
PLAY

Over four nights and three days, the Boruca indigenous people commemorate their confrontation with the Spaniards in the traditional celebration *Juego de los diablitos* (Game of the Devils). On the last day, the battle seems to be lost when the Spanish conqueror, represented by a bull, manages to knock down all the masked indigenous people, but a village elder plays a conch to bring them back to life. The figure of the bull ends up getting burned and the little devils celebrate!

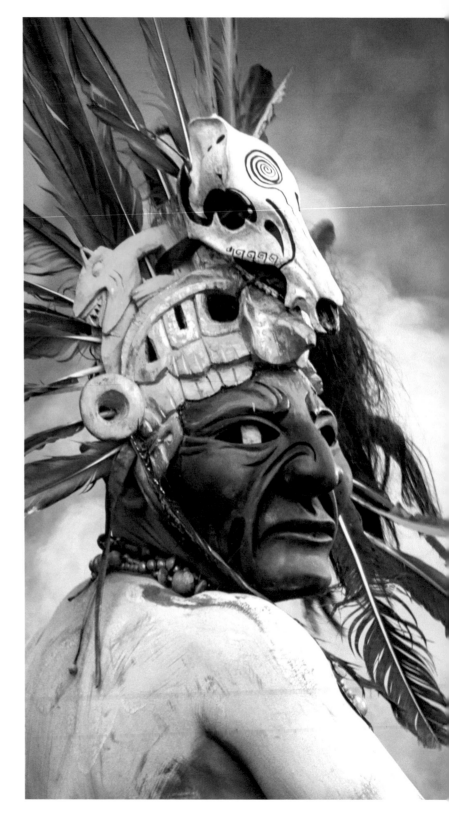

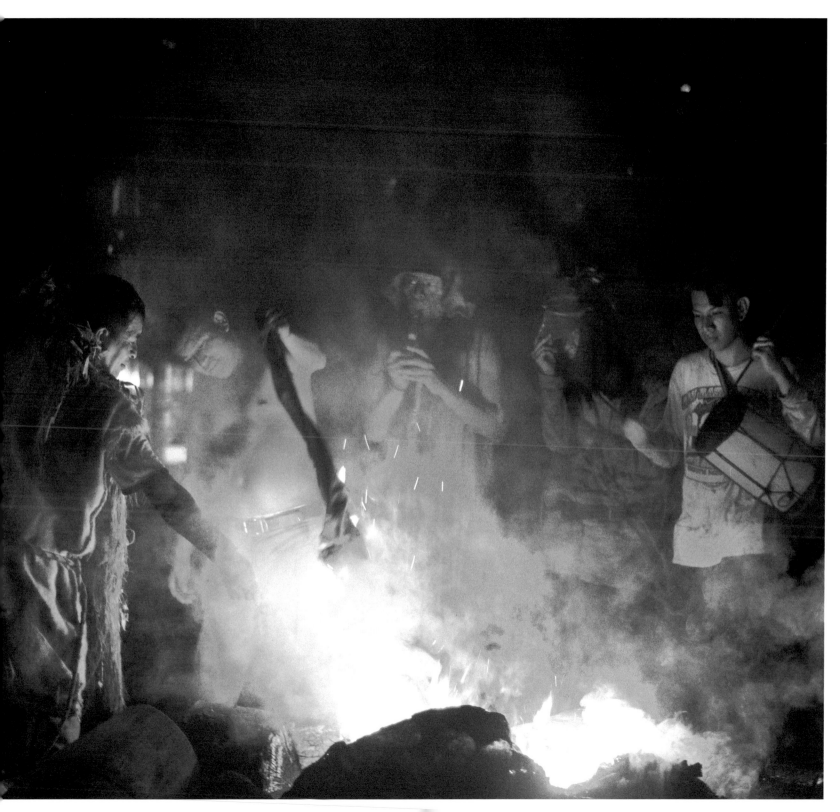

THE BANANA PLANTATION

The Banana Company partitioned its empire in Palmar Sur into farms of about 500 to 1000 acres (200 to 400 ha), each a unit of production and a home for workers. They were named, unpoetically, with numbers, from 1 to 20. At the center was a soccer field, which was surrounded by the homes of workers, the boss, and some mid-level employees; the perimeter was also dotted by warehouses. With no other social or recreational services, this central field was the hub of life on the banana plantations.

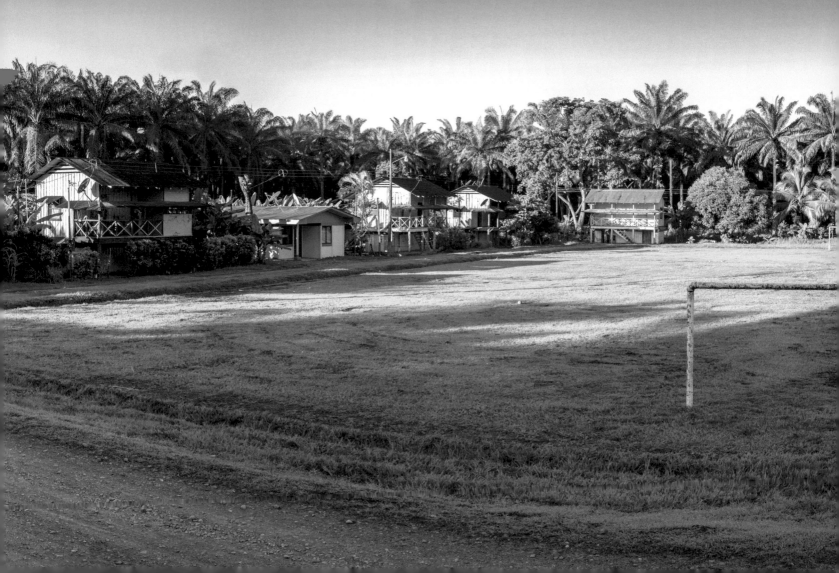

Plantation of African oil palms, Parrita

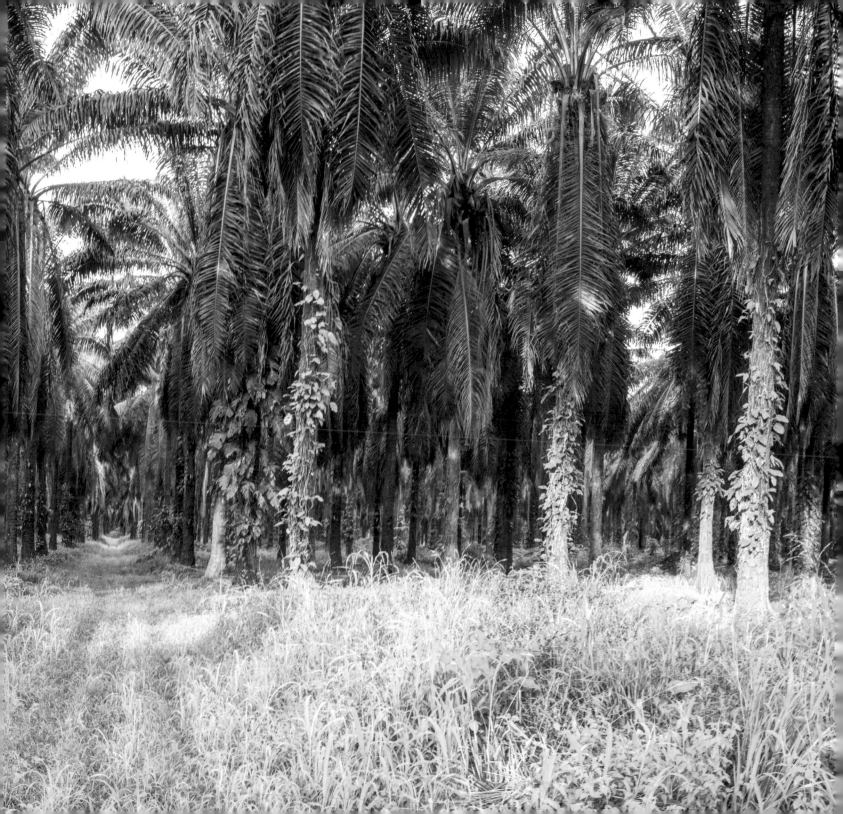

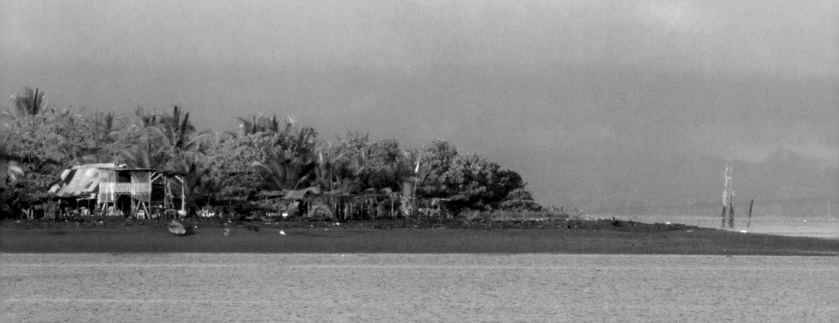

Like Russian dolls, Golfito is a small gulf within a larger one, Golfo Dulce. The city of Golfito went from being the favorite of the banana empire in the South Pacific to being just another coastal town with few employment op- **THE TINY** GULF portunities. When the "Company" left, the area first tried tax-free sales at the Duty Free zone to attract visitors; today, city planners hope to lure local and international tourists.

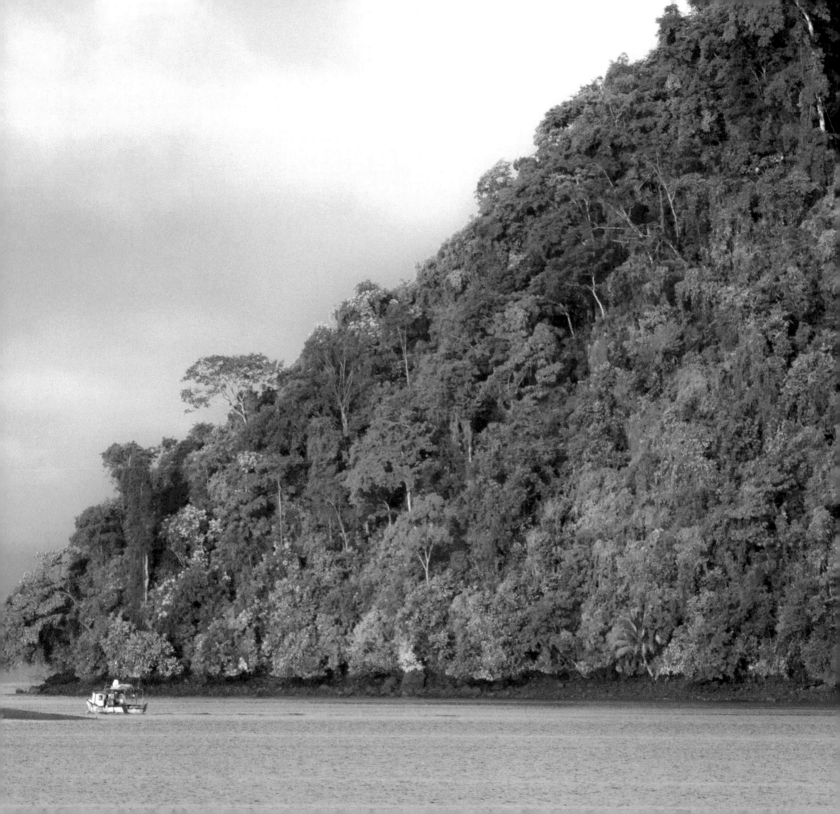

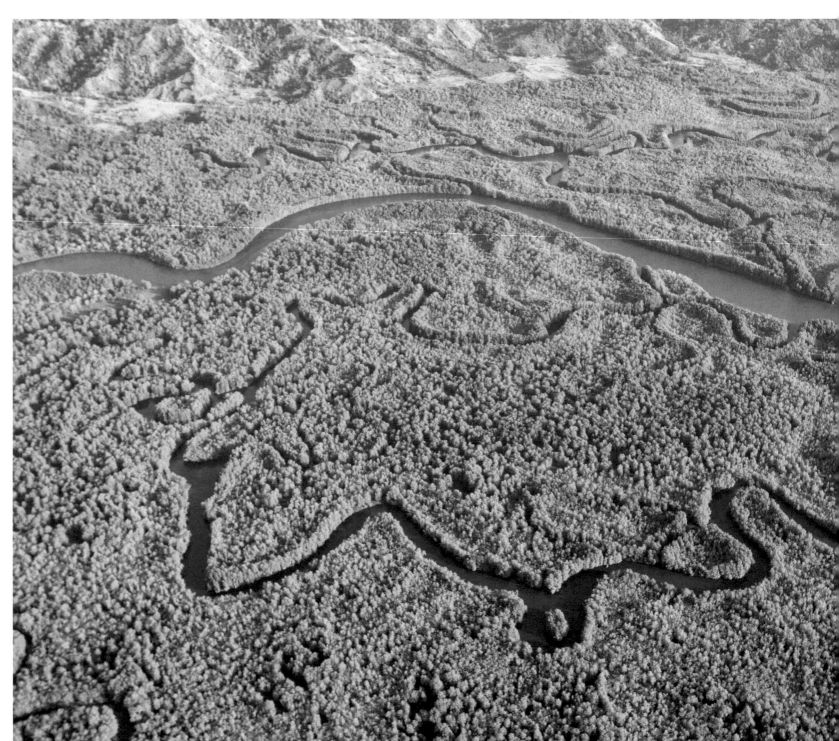

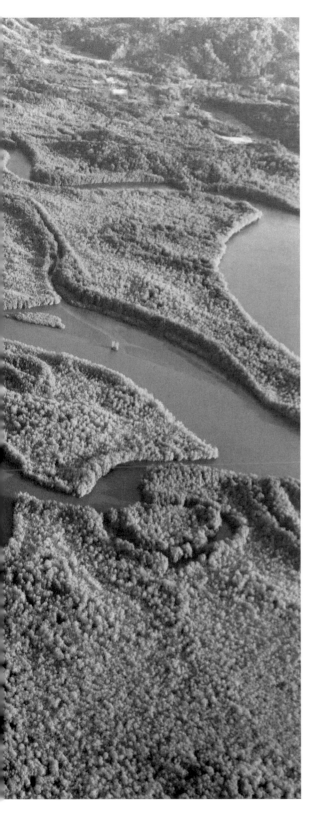

THE MEANING
OF MUD

The Río Sierpe, along with a labyrinth of canals, mangrove roots, and beaches, forms the largest wetland on the Costa Rican Pacific. It teems with life. In this borderland world between land and sea, mud takes on a new meaning. These lands guard the entryway to the south and hold an enormous amount of carbon in their soils.

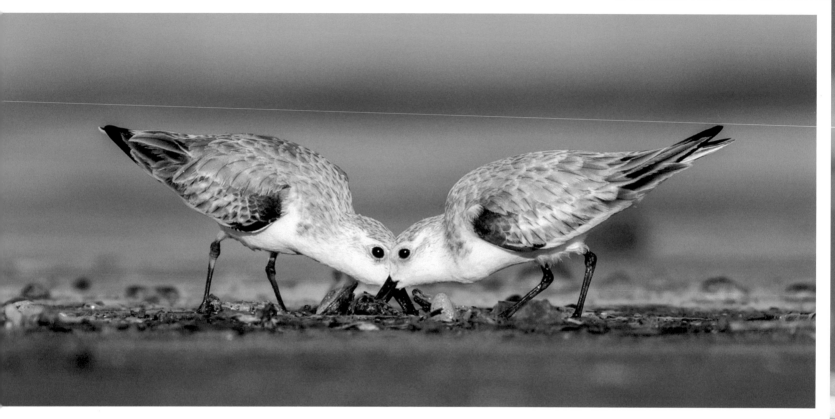

Some sandpipers like the sanderling (*Calidris alba*) arrive from August to September, as summer in the north comes to an end. They wander along the beach inserting their small bills into the sand in search of insects, small mollusks, and worms. The anhinga (*Anhinga anhinga*) is a resident bird and an expert diver that hunts by diving and using its bill as a spear that it drives into its prey.

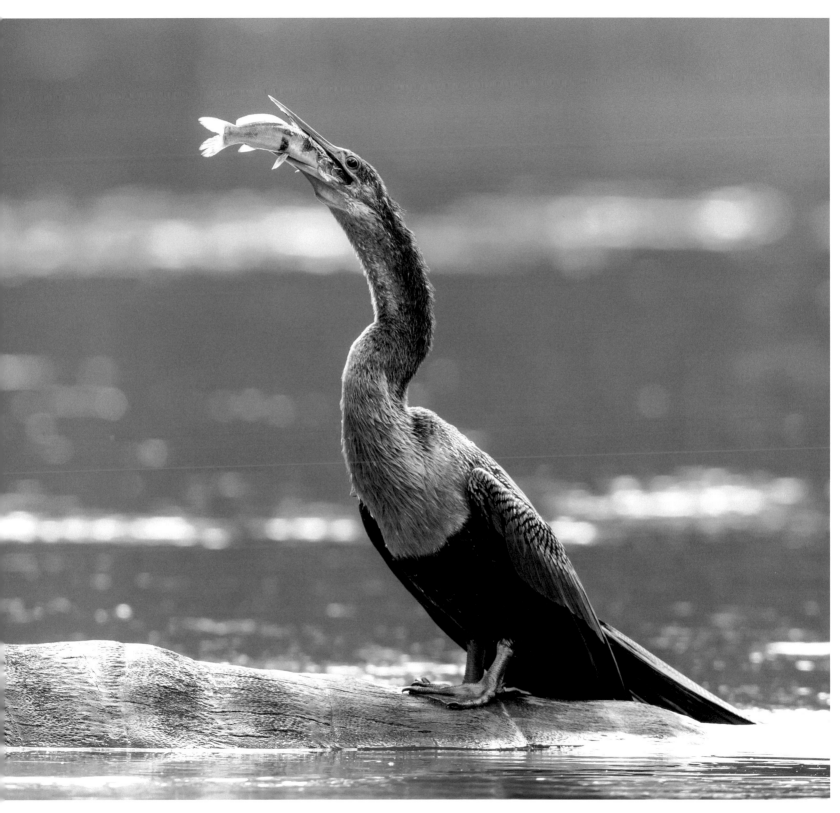

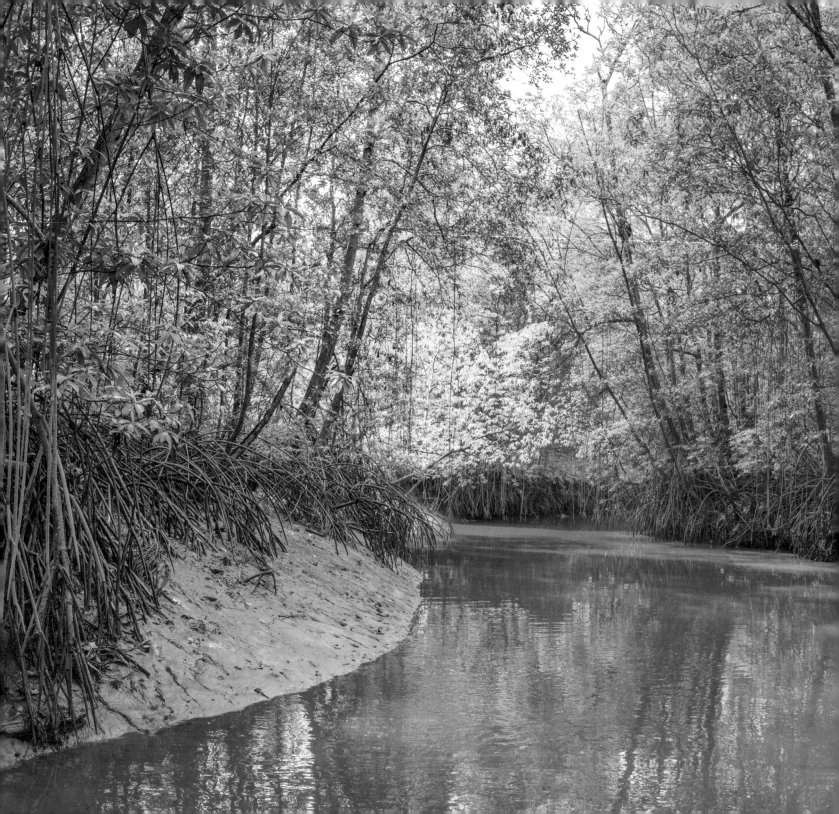

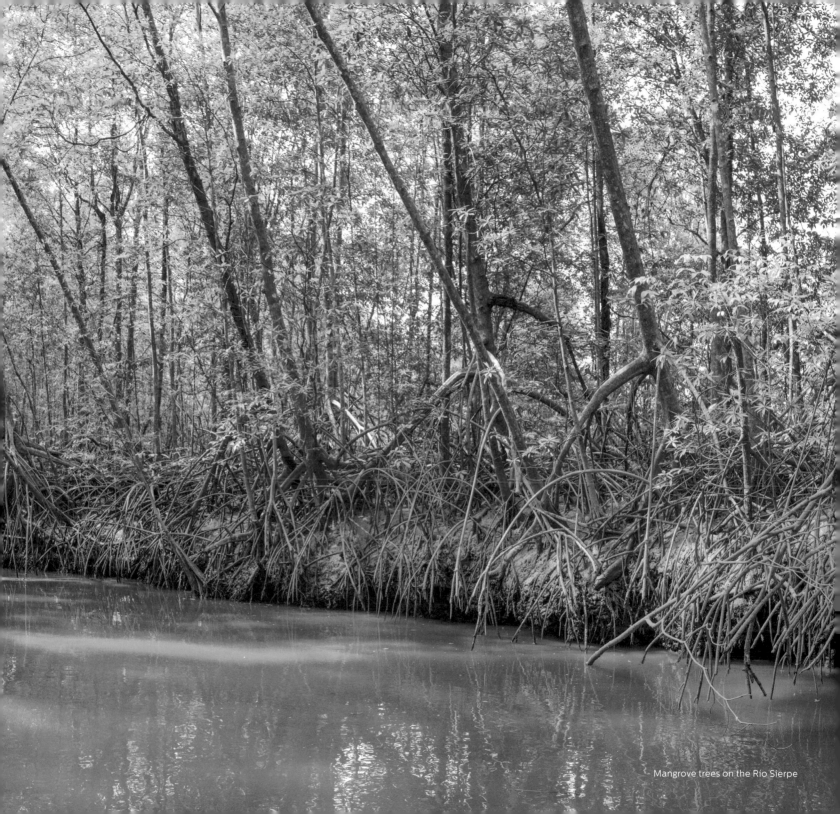

Mangrove trees on the Río Sierpe

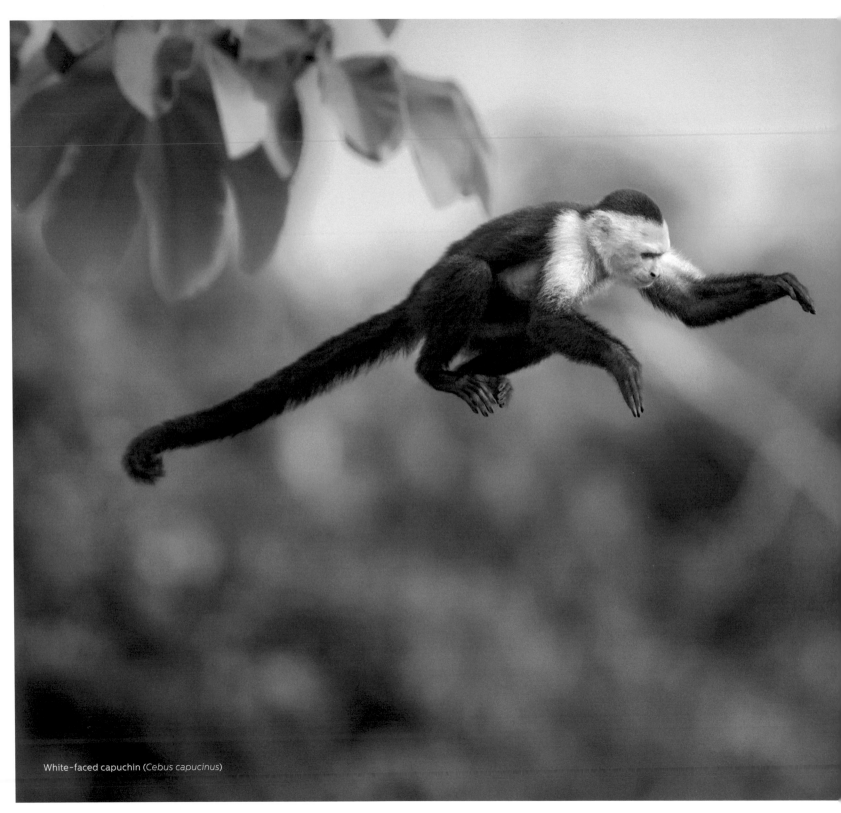

White-faced capuchin (*Cebus capucinus*)

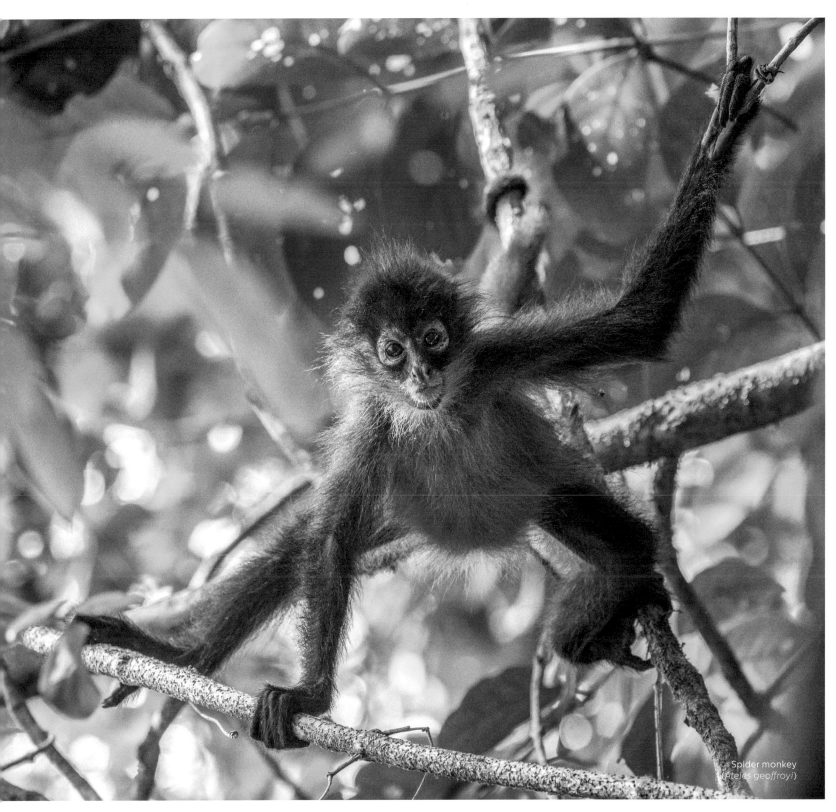

Spider monkey
(Ateles geoffroyi)

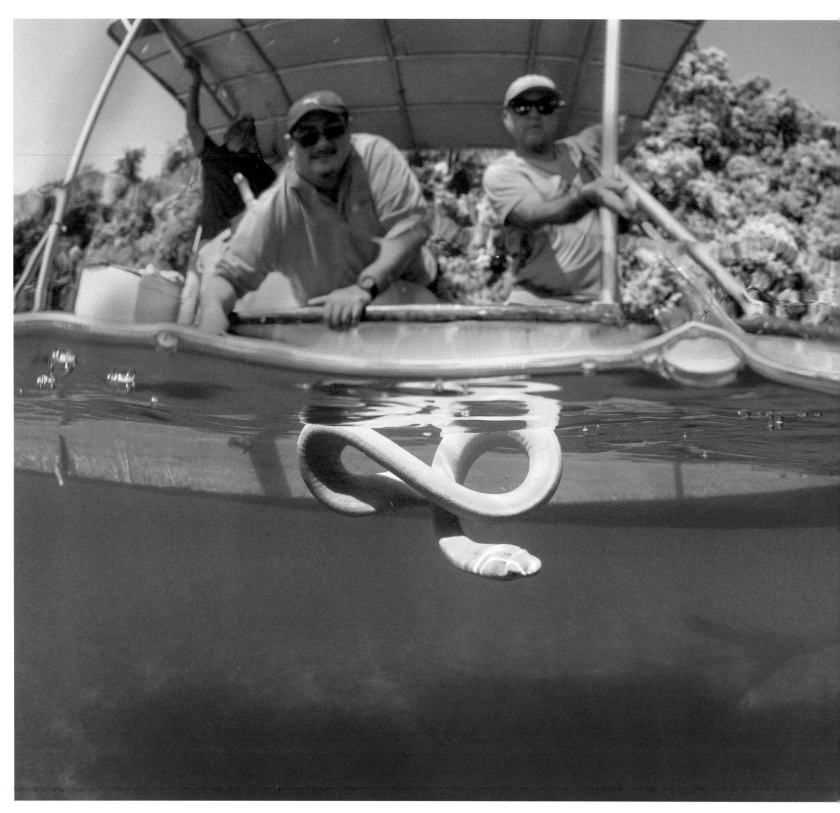

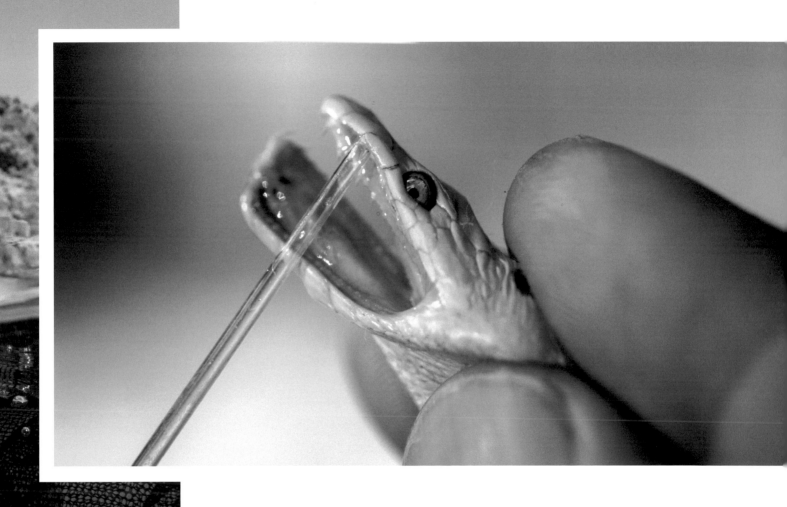

In all other tropical seas, the venomous yellow-bellied sea snake (*Hydrophis platurus*) has a body that is half black and half yellow. But here in the Golfo Dulce, there is a unique population that is completely yellow. What evolutionary forces could have resulted in this change? The answer still eludes us, but local biologists are researching the genetic patterns of both populations to try to reach an answer.

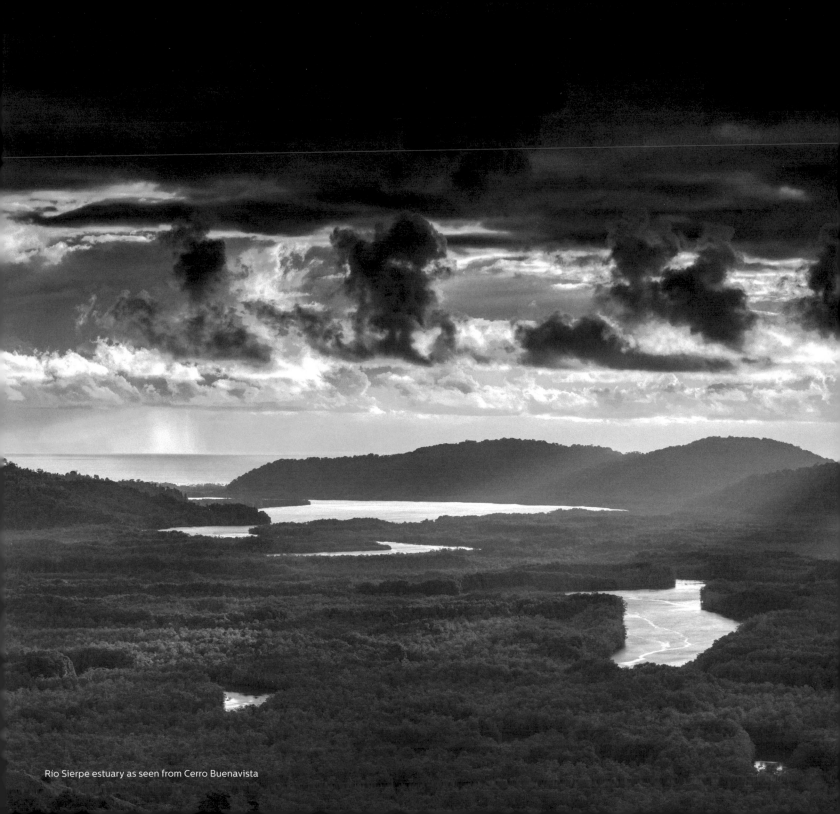

Río Sierpe estuary as seen from Cerro Buenavista

ROAD
TO THE
SOUTH

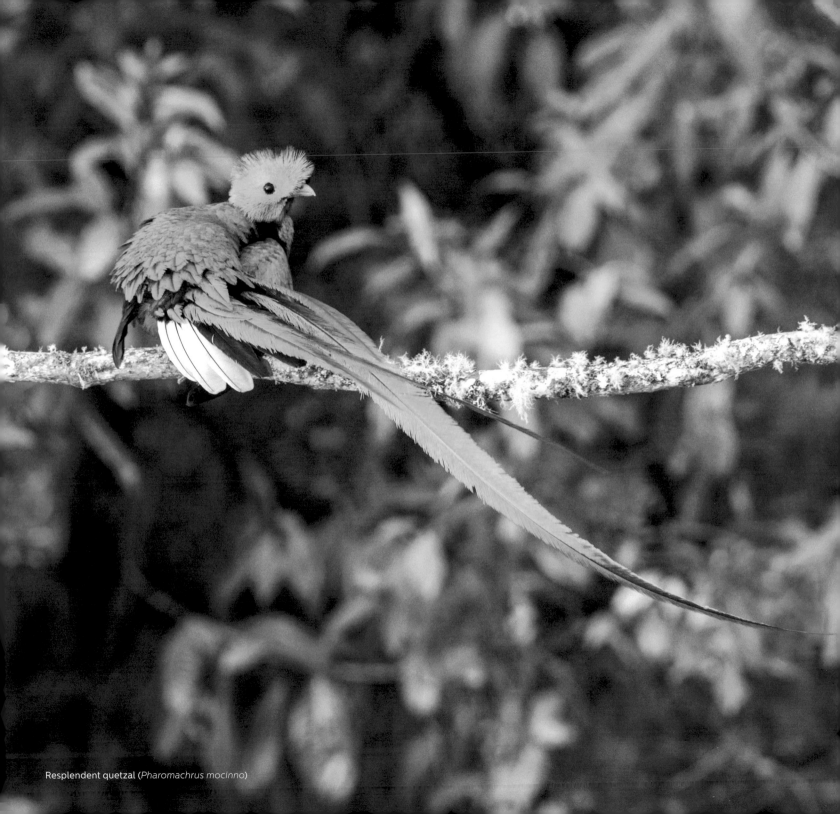

Resplendent quetzal (*Pharomachrus mocinno*)

The guide directs our gaze with his finger, but the bird remains hidden. "Come, crouch down," he tells me, as he also kneels on the trail. "See that big tree? Follow the second branch. There." And then I catch a glimpse of the miraculous bird: amid the moss colored leaves, there is an emerald shine, barely noticeable. The guide adjusts the focus of his telescope and the face of a male quetzal (*Pharomachrus mocinno*) appears in the lens, its very round eyes, tiny bill, and unmistakable red breast on full display. The bird feeds in an aguacatillo (*Ocotea* sp.), a species of avocado tree that produces its favorite food, and when it takes flight, its common name, resplendent quetzal, becomes embodied before our very eyes. Resplendent indeed, with no hyperbole.

It is one of the most spectacular animals in Costa Rica and lives just a stone's throw from the Pan-American Highway,

one of the main traffic arteries of the country. This road, which connects the Central Valley and capital city with the southern region of the country, passes through quetzal territory and then leads to several other natural wonders: the largest wetland in Costa Rica, the dense jungles of Corcovado, and the azure waters of Golfo Dulce, to mention a few.

But wherever it leads you finally, the road itself traverses one of the best kept secrets in Costa Rican ecology: the ecosystems of the Talamanca Mountains, including cloud forest, paramo, and never-ending oak forests.

For years, this mountain range was an imposing barrier, and indeed up through 1945 those who traveled by land from San José to San Isidro de El General went on foot or by wagon. The three or four days through the inhospitable

terrain led travelers to give the highest peak on the route the grim name of Cerro de la Muerte (Mountain of Death). To ease the journey, the government built three mountain shelters where people could spend the night, somewhat protected against the cold. Finally, the extension of the Pan-American Highway made the trip more pleasant and reduced travel time.

To preserve the oak forests through which the highway passes, there were calls in 1945 to designate the area a national park. While these efforts were unsuccessful, large tracts of oak forest survive today in a mosaic of protected areas on both sides of the highway. These include Los Quetzales National Park, Tapanti National Park, Los Santos Forest Reserve, and Cerro Las Vueltas Biological Reserve.

Farmers in the Tapanti region have formed an alliance with hotel owners and will notify guides when they spot a quetzal on their land. These farmers appreciate the beauty of this majestic bird as much as anyone else, but they are also happy to receive a fee for each tourist who arrives on their land to photograph the quetzals.

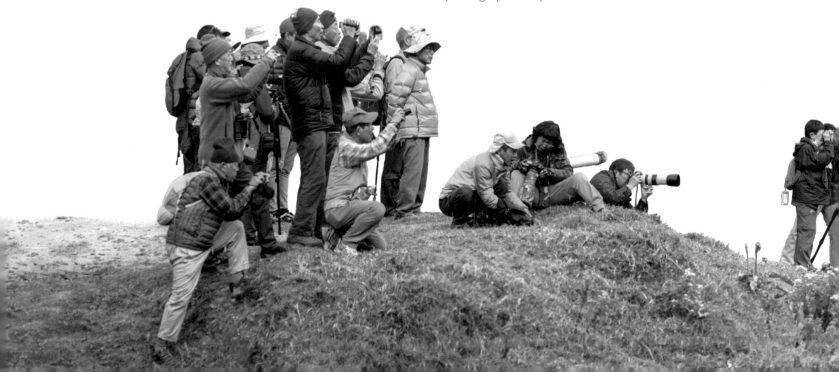

The bond between humans and quetzals is ancient. For many indigenous communities, it was a sacred animal; in Nahuatl, the term *quetzalli* can be translated as "long tail of brilliant feathers." This bird favors cloud forests; in Costa Rica, it resides both in the cloud forest of this region and in Monteverde, though it does move to lower elevations in search of food.

As the quetzals flit about the forest canopy, several stories below them—on the forest floor—lives the tapir (*Tapirus bairdii*), the largest mammal in the Neotropics. They lumber through the understory, making trails as they do so, dispersing seeds, and nibbling on new shoots, from which behavior they have been named the "gardeners of the forest." For many decades, illegal hunting reduced their numbers. And today they face a new threat from the vehicles that travel along the southern part of the Pan-American Highway, which bisects this mammal's habitat. In just one year, nine of these animals were killed by cars, a significant figure given that tapirs have only one offspring at a time and care for their young for two years.

For millennia, the Talamanca Mountains have existed in isolation, separated from other highland regions by the surrounding plains. Such biological "islands" foster endemism. Scientists estimate that 30–40% of the flora of these mountains is endemic and the plants and trees are home to several endemic bird species like the fiery-throated hummingbird (*Panterpe insignis*), timberline wren (*Thryorchilus browni*), and peg-billed finch (*Acanthidops bairdii*).

Among these mountains is Cerro Chirripó, the highest point in the country and a mecca for local mountain climbers. The pilgrimage to the top, 12,536 feet (3821 m) above sea level, attracts people from the entire country. The journey begins in San Gerardo de Rivas, a small town at the base of the mountain, 8.7 miles (14 km) from the lodge, where hikers spend their first night near the summit. While indigenous communities made this region theirs centuries ago, the first visits by non-indigenous climbers were not recorded until the 20th century. In 1958, the Mountaineering Club of the University of Costa Rica installed the first waterproof box so that people who reached the top could record their arrival in a guest book, as is done on European peaks.

There is something preternatural about Chirripó, whose almost lunar terrain is unlike anything found in the rest of the country. Average temperatures of 41 °F (5 °C), grayish shrubs, and moraines—signs from the last glaciation—create a sense of splendid isolation. This is paramo, one of the most specialized ecosystems, and in Costa Rica it is found only at the highest elevations of Cerro Chirripó and Cerro de la Muerte. But this ecosystem is threatened by climate change: as temperatures rise, vegetation types and animals from lower elevations will migrate up the mountain slopes, leaving the paramo nowhere to go. Little by little, it moves up the slope, seeking a higher ground that does not exist.

The big sister of this group of protected areas in Talamanca is La Amistad [Friendship] International Park, so-called because the neighboring nation of Panama also protects these mountains. The protected area on the Costa Rican side is nearly 500,000 acres (199,000 hectares), mostly on the Caribbean slope; in 1983, UNESCO designated these forests a World Heritage Site for their biological richness.

Descending down the mountain slopes of this region, approaching the floodplains of the El General valley, conservation efforts give way to sugar cane

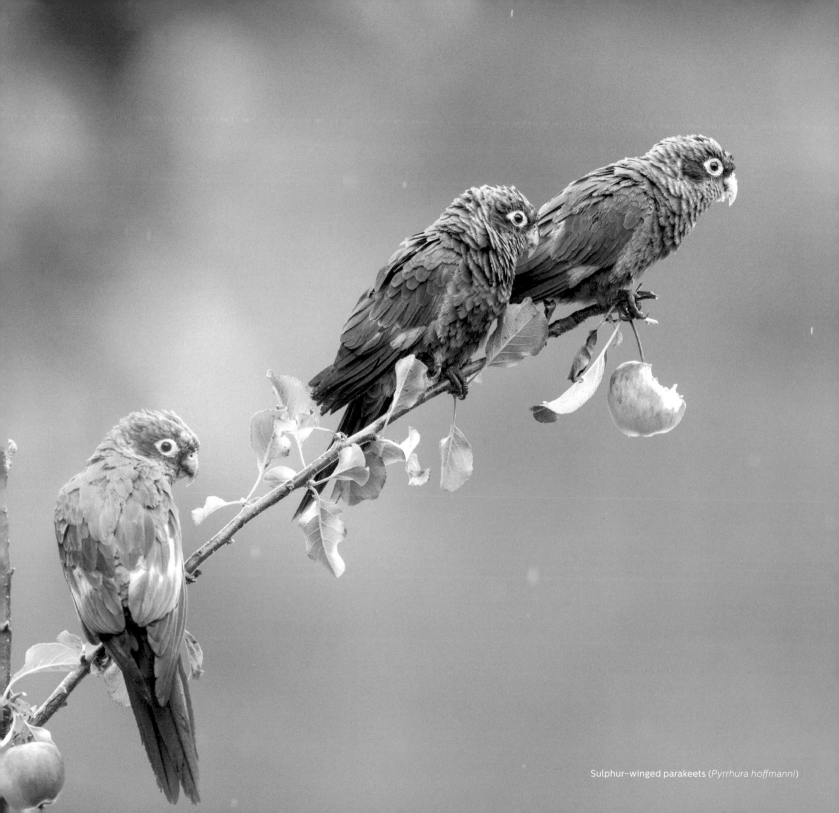

Sulphur-winged parakeets (*Pyrrhura hoffmanni*)

and pineapple plantations. But not all is lost—several oases survive in the lowlands, among them the Alexander Skutch Bird Sanctuary, a farm named after the biologist who lived there for decades. Originally from the United States, Skutch was a pioneer in Costa Rican ornithology, one of the most renowned experts in the country. He named his farm Los Cusingos in honor of the local common name for the fiery-billed aracari (*Pteroglossus frantzii*), also endemic to the region. Here, at the foot of the Talamanca, birders arrive in search of the 254 bird species that occur here, both residents and migrants.

On the trail through these lowland jungles, a world apart from the cloud forest, another guide points his finger, this time in the direction of an orange-collared manakin (*Manacus aurantiacus*). Again, at first glance, the bird is not to be seen. But then there is a rustle of leaves and a flash of color ...

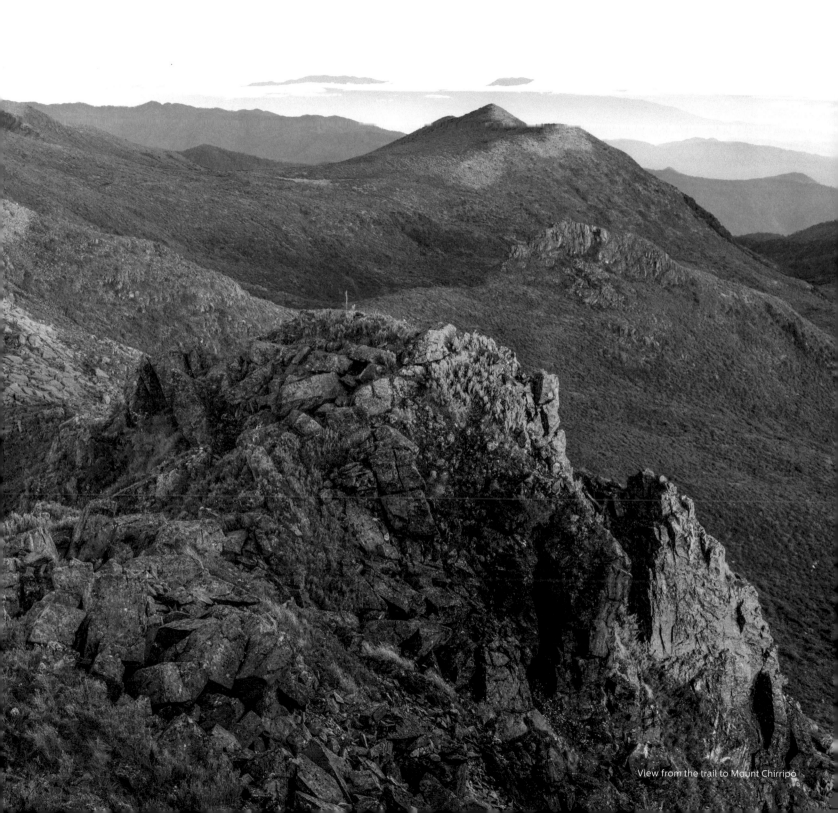
View from the trail to Mount Chirripó

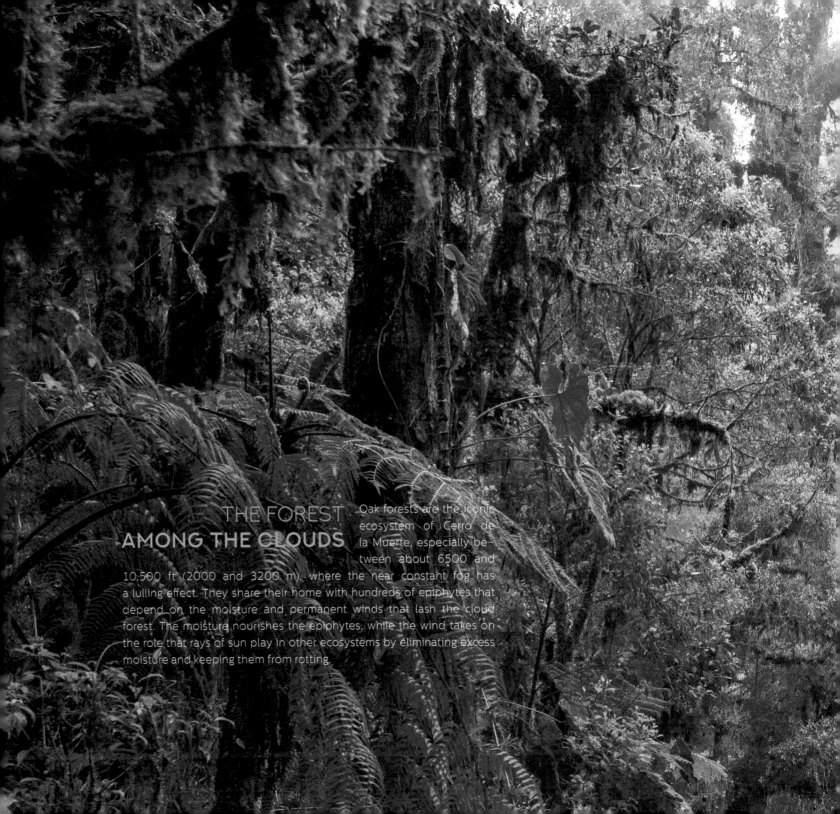

THE FOREST
AMONG THE CLOUDS

Oak forests are the iconic ecosystem of Cerro de la Muerte, especially between about 6500 and 10,500 ft (2000 and 3200 m), where the near constant fog has a lulling effect. They share their home with hundreds of epiphytes that depend on the moisture and permanent winds that lash the cloud forest. The moisture nourishes the epiphytes, while the wind takes on the role that rays of sun play in other ecosystems by eliminating excess moisture and keeping them from rotting.

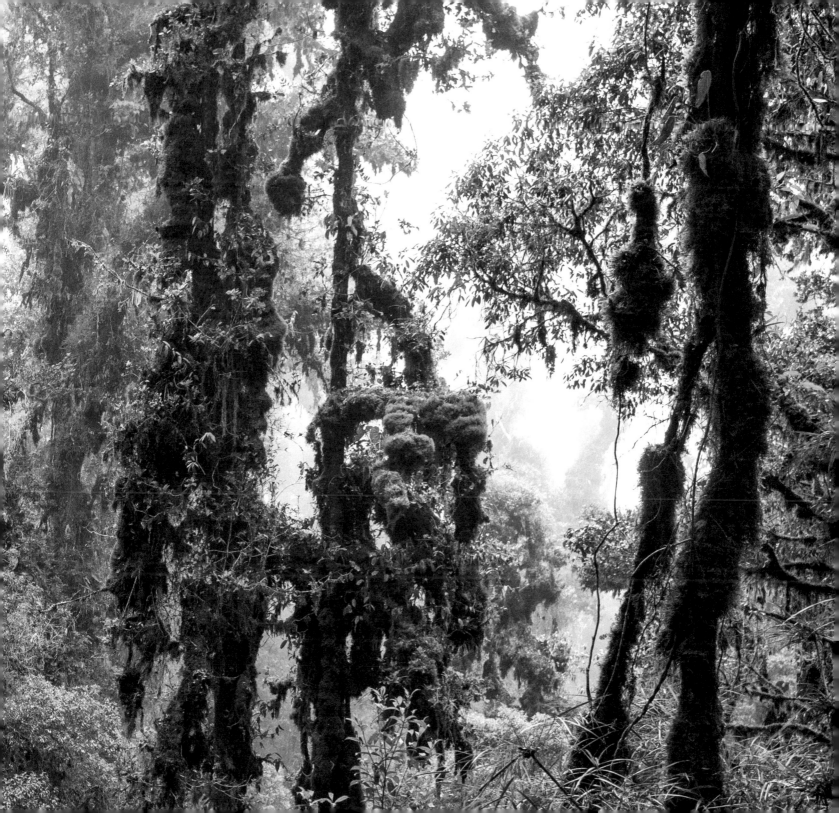

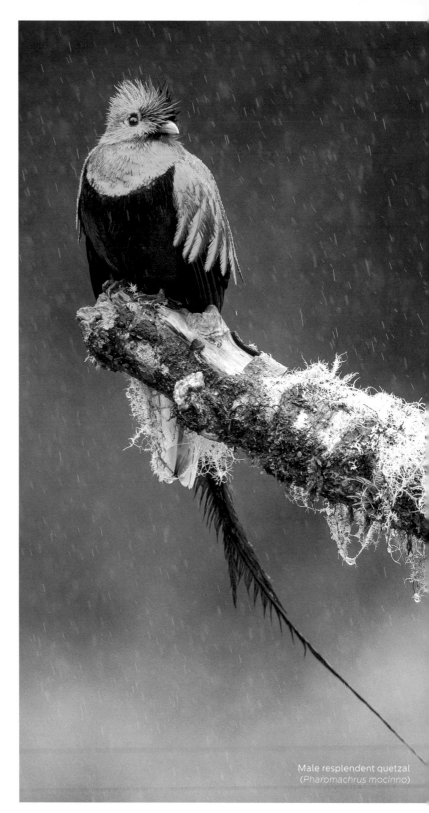

GREEN
TOURISM

The Kabek Project took on a big challenge in 2011, when it began promoting the conservation of lands in the Cerro de la Muerte, home to quetzals. Farmers alert tour guides at Paraíso del Quetzal Lodge when they find these birds feeding in their pastures, and that is how the tourists arrive. Afterward, each farm is given $5 per visitor. Both the tourists and the farmers, however, must follow a set of rules so as to not disturb the quetzals.

Male resplendent quetzal
(*Pharomachrus mocinno*)

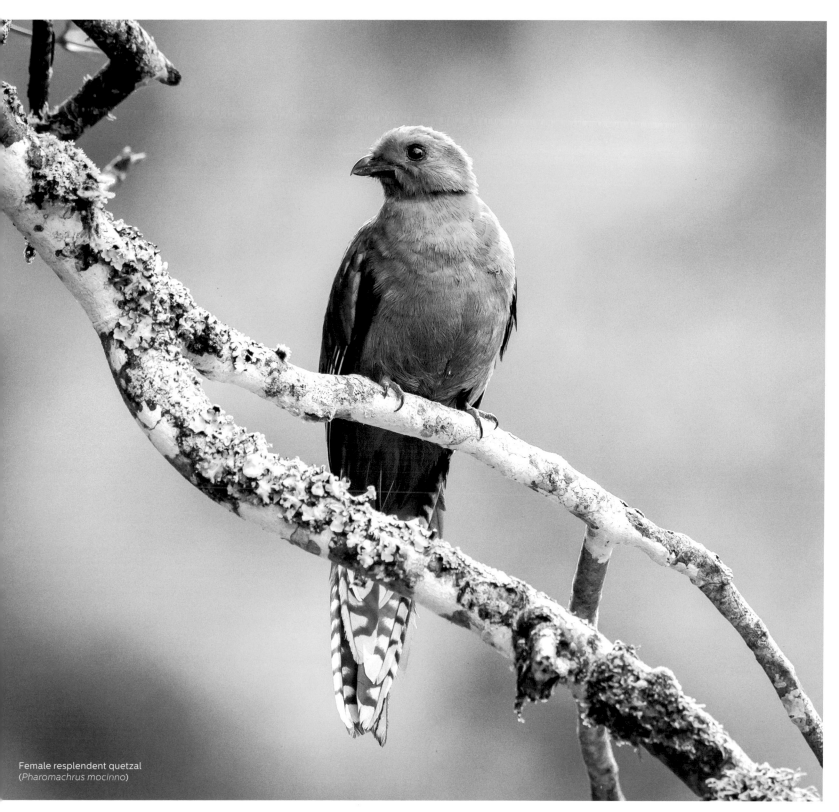

Female resplendent quetzal
(*Pharomachrus mocinno*)

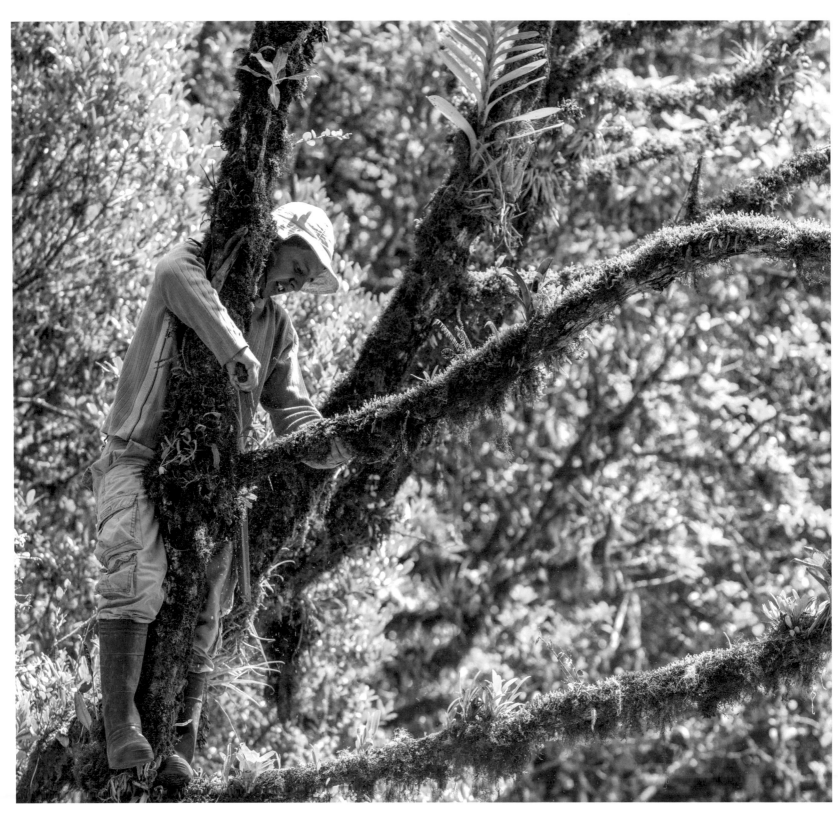

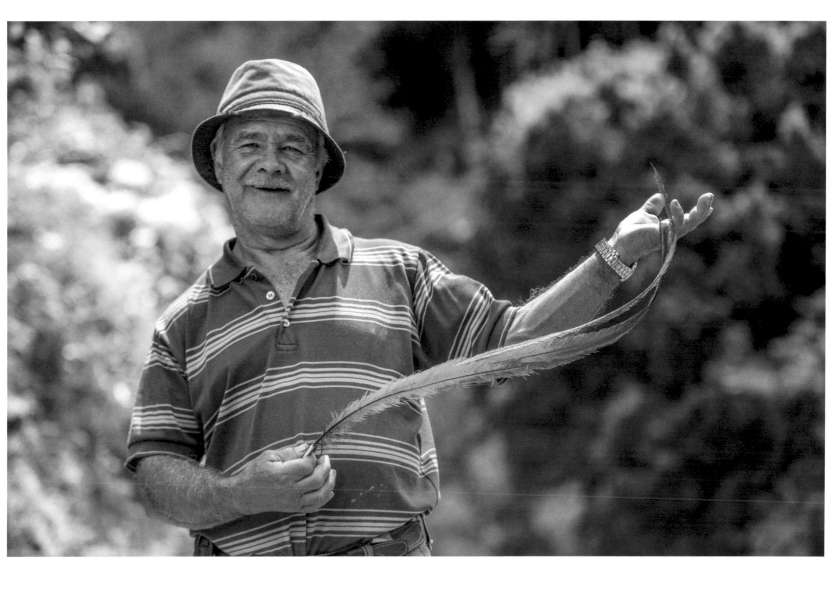

In addition to promoting responsible tourism, the Kabek Project builds artificial nests for the quetzals and prunes and cares for the *Ocotea* trees on whose fruits the birds feed. While the project does financially incentivize local farmers to protect the bird populations, it also seeks to instill in the locals a sense of pride in this iconic creature that people from around the world come to see.

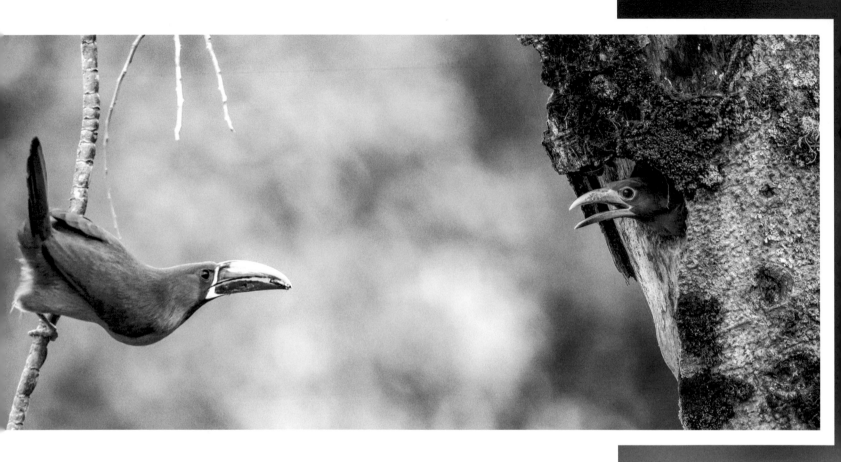

Among the most charismatic species that have been affected by climate change is the emerald toucanet (*Aulacorhynchus prasinus*). Although it once lived at altitudes between 2625 and 7874 feet (800 and 2400 m), in recent years it has had to move higher and higher to nest. As a result, the toucanet has become a threat to the quetzal, on whose eggs it preys—and both species compete for the few available nesting sites. To help ameliorate the effects of this territorial overlap, the Kabek Project has focused on the task of building artificial nests.

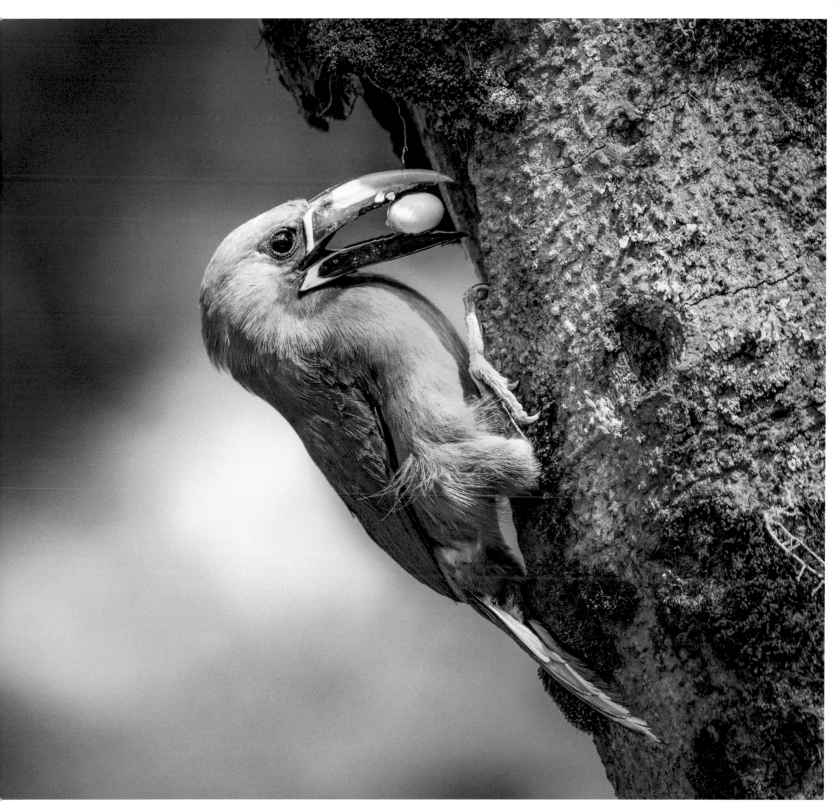

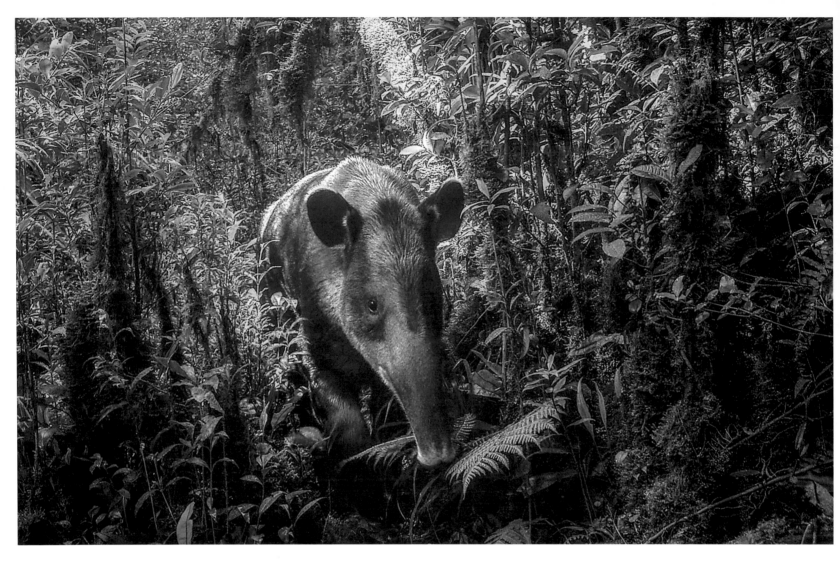

Tapirs (*Tapirus bairdii*) are the largest mammals in the Neotropics, and they have essential ecosystem functions such as controlling vegetation, opening space for new sprouts, and dispersing seeds. On Cerro de la Muerte, this animal's habitat is split in two by the Pan-American Highway, and each year several are killed by vehicles. Organizations like Naï Conservation work to protect tapirs by putting up road signs, giving talks at schools, and forming alliances with hotels and guides.

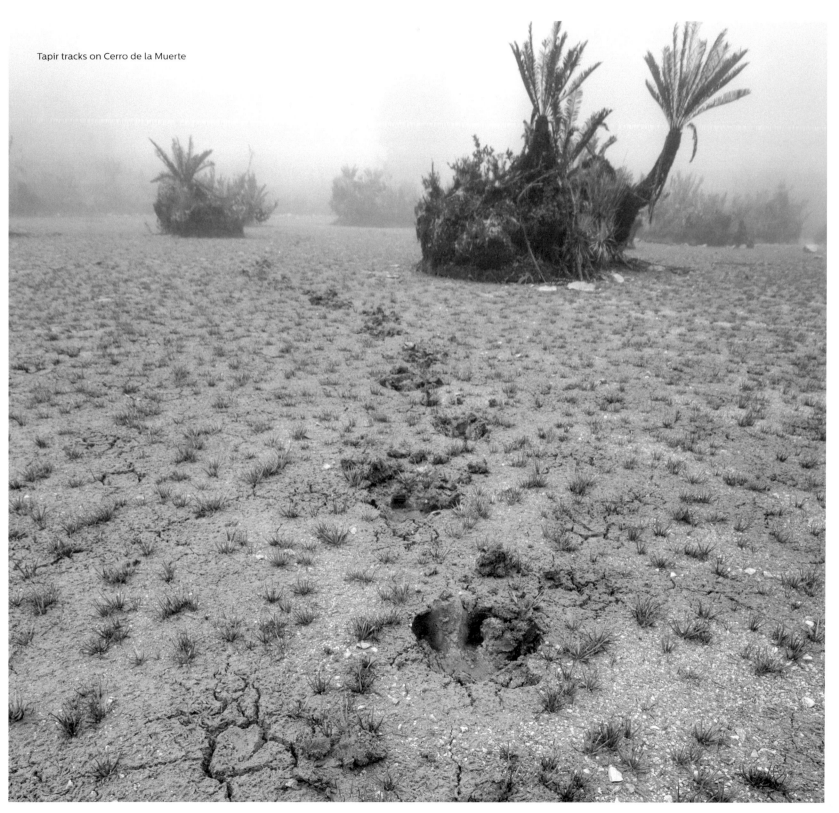

Tapir tracks on Cerro de la Muerte

CARBON
BANK

Few people know that there are high elevation wetlands, known as peat bogs, in Costa Rica. The low temperatures retard the speed of decomposition, which facilitates the accumulation of organic matter: a peat bog can have up to 10 times more carbon stored in its soils than a forest.

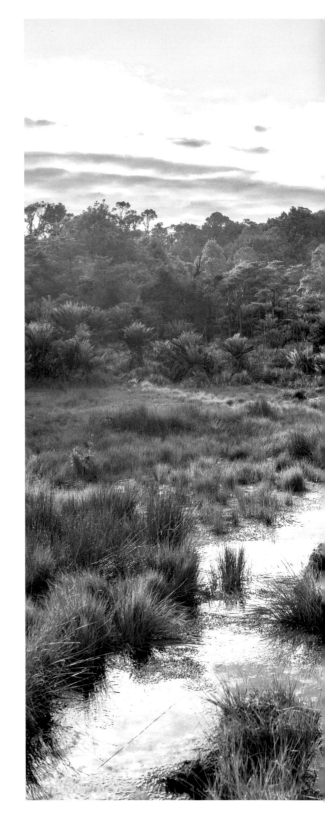

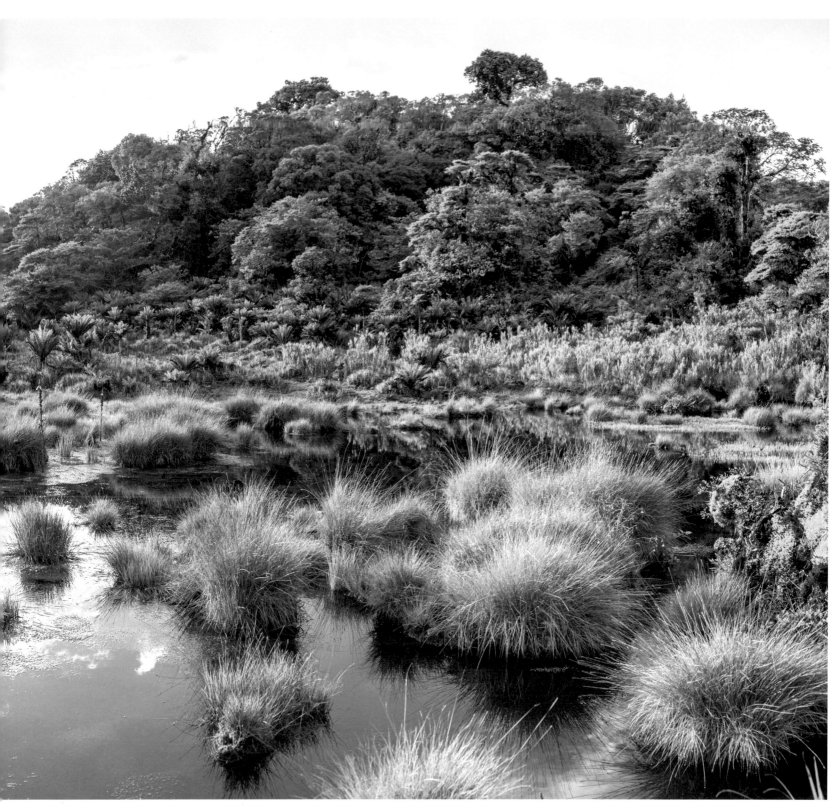

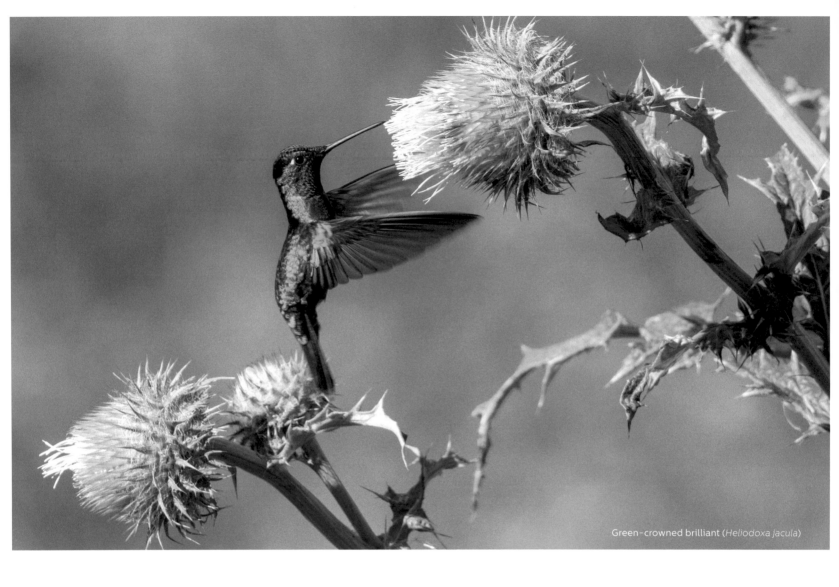

Green-crowned brilliant (*Heliodoxa jacula*)

Of the 50 hummingbird species that occur in the country, a staggering 17 are endemic, either to Costa Rica or a small region; the fiery-throated hummingbird, for example, lives in both this country and western Panama. Most of the species, including the green-crowned brilliant, live at middle elevations, between 655 and 7218 feet (200 and 2200 m).

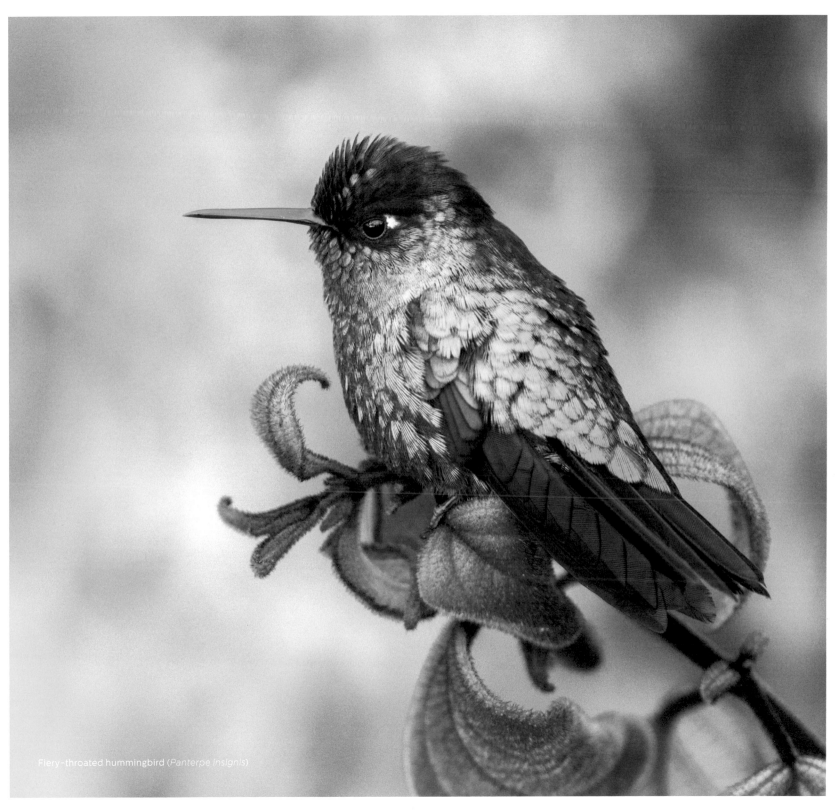
Fiery-throated hummingbird (*Panterpe insignis*)

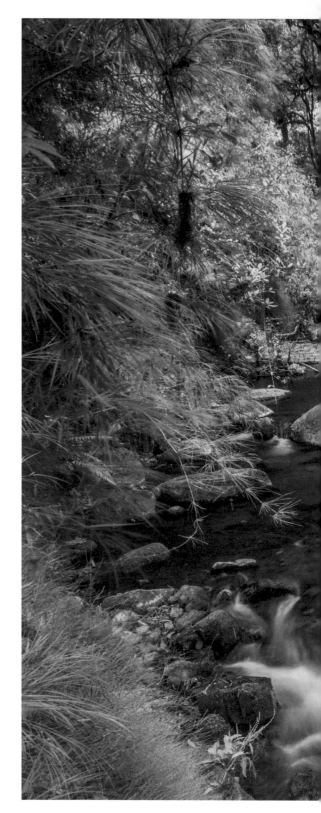

WATER AND
ELECTRICITY

Tapanti–Cerro de la Muerte's most important national park–could as well be a synonym for water. Indeed, the copious rain on these peaks feeds the waterfalls, dams, and hundreds of rivers and streams that cross through the oak forests downslope. There are over 150 rivers that flow toward the Caribbean, all with great hydroelectric potential, among them those that feed into Rio Reventazón, a key contributor to the country's electrical system. At the same time, one million people from the Central Valley depend on the water supply from Tapantí National Park, which provides electrical power and potable water.

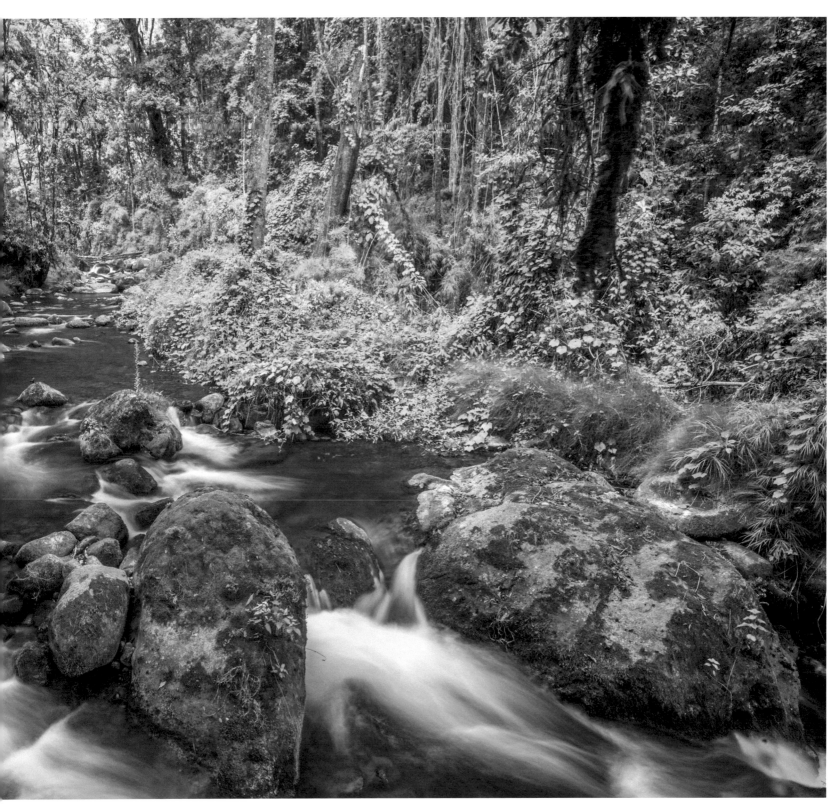

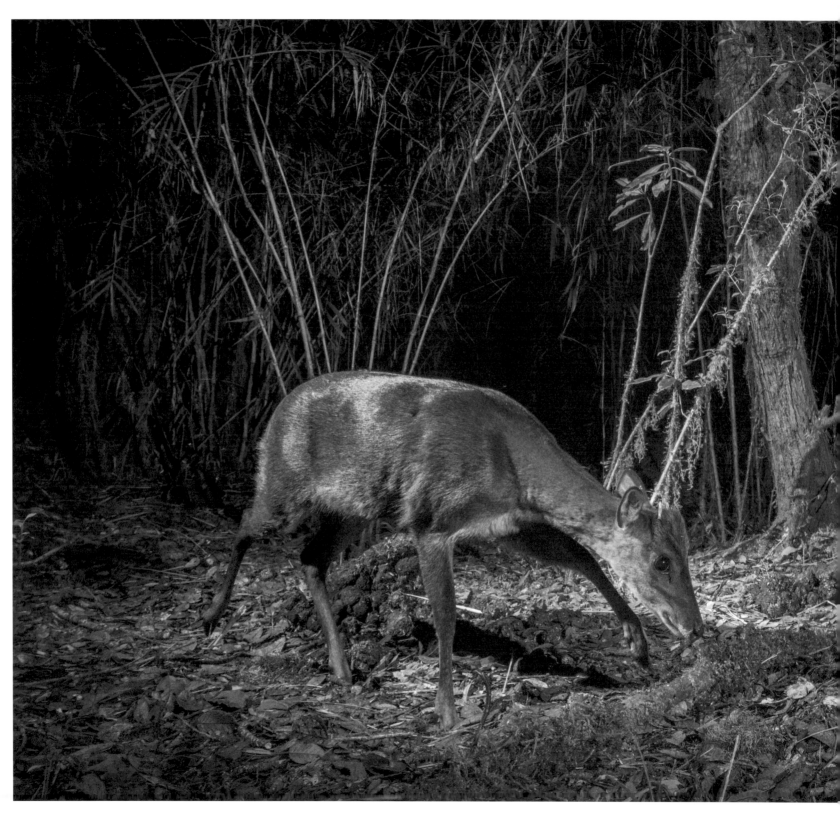

FURTIVE
CREATURES

Camera traps have become a great help to scientists who work on Cerro de la Muerte. Thanks to them, they can monitor even the wariest of animals, such as this red brocket deer (*Mazama temama*), here lurking around a tapir "latrine" in Los Quetzales National Park. Its presence on these mountains is important, because it serves as food for all types of large carnivores like jaguars and pumas.

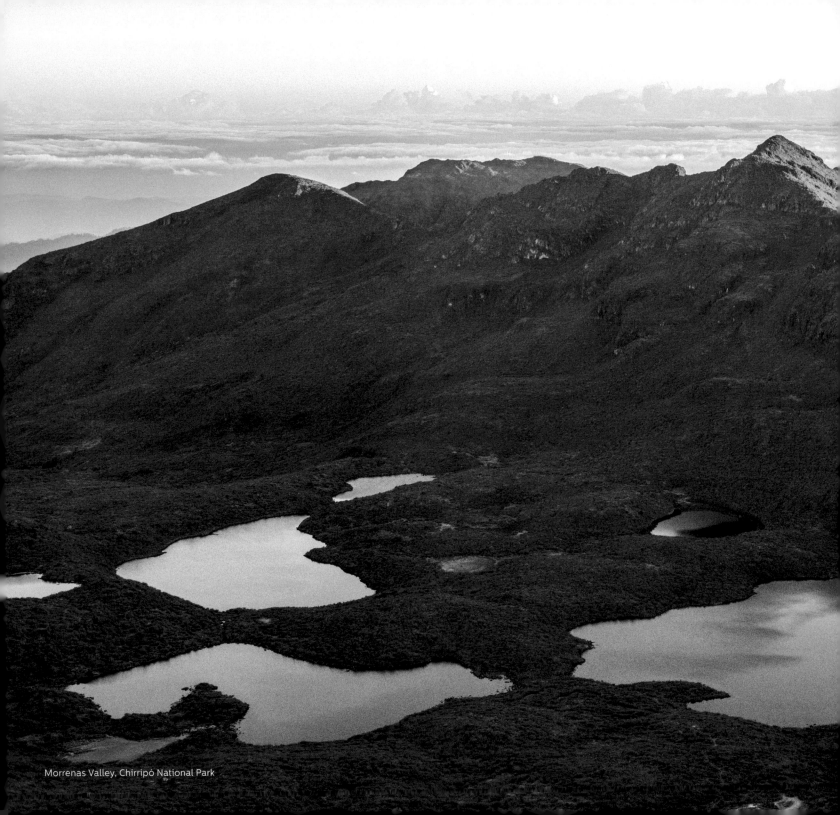

Morrenas Valley, Chirripó National Park

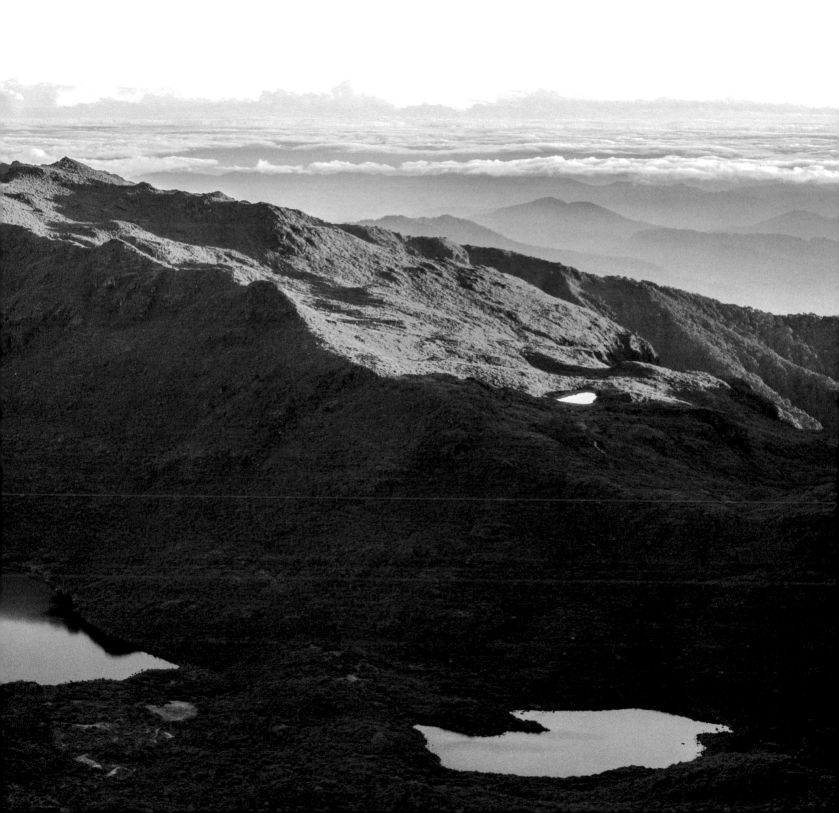

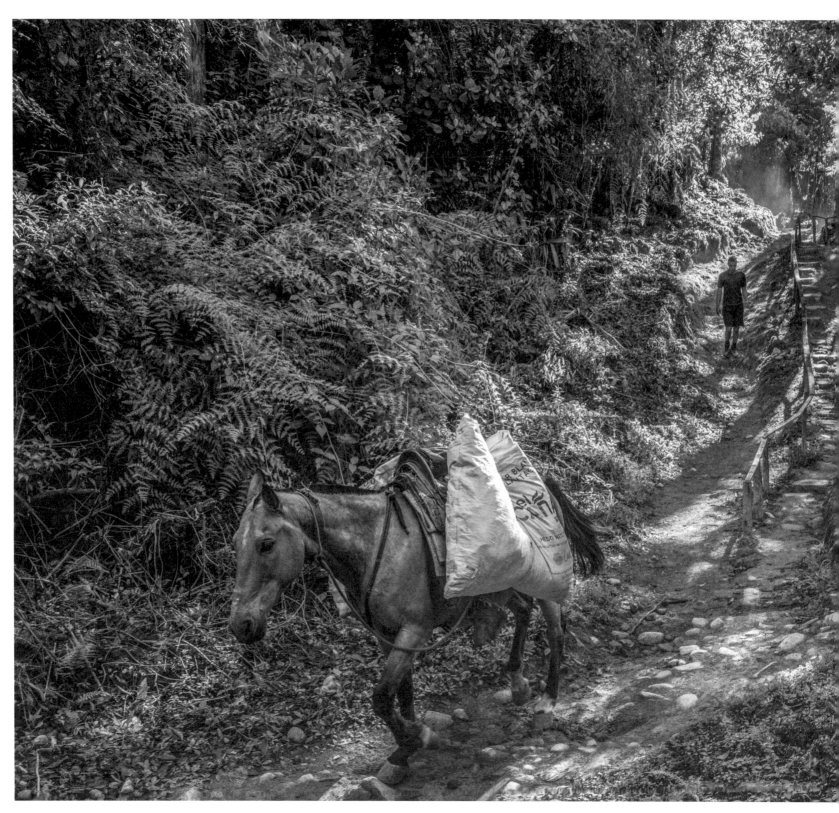

9 MILES STRAIGHT UPHILL

The steep path that leads up Cerro Chirripó—the tallest peak in Costa Rica at 12,536 ft (3821 m) in elevation— begins at Rivas and wends its way up the mountain. An arduous hike under any circumstances, some climbers opt to hire local help to carry their backpacks up to the summit for them.

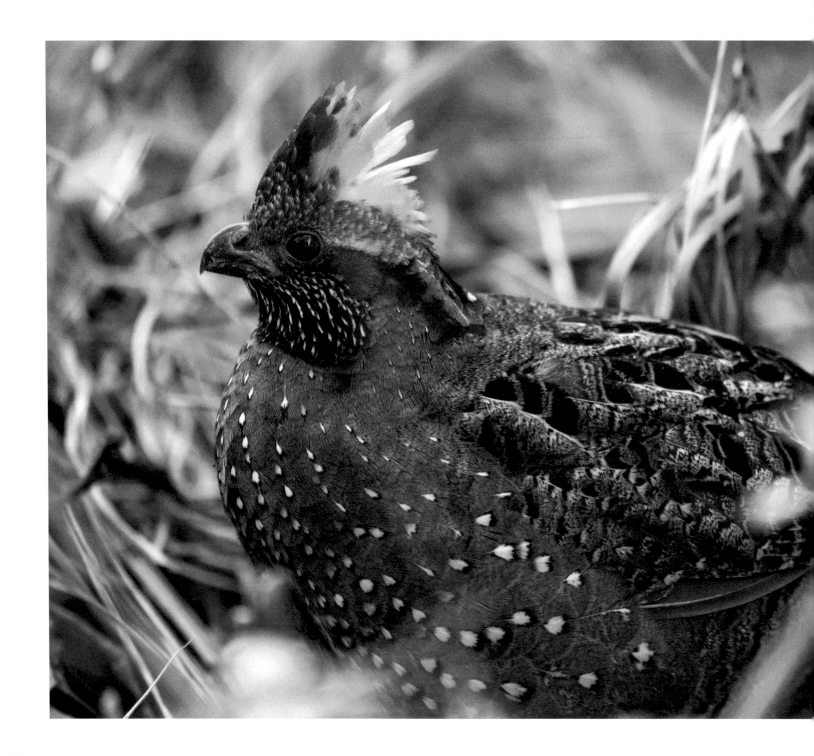

On the challenging, steep route to the top of Chirripó, birdwatching can provide an excuse for a few well-deserved minutes of rest.

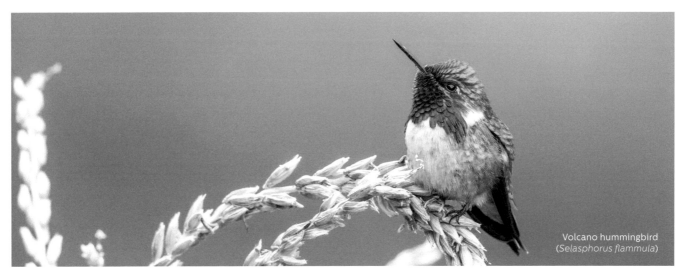

Volcano hummingbird
(*Selasphorus flammula*)

Spotted wood-quail (*Odontophorus guttatus*)

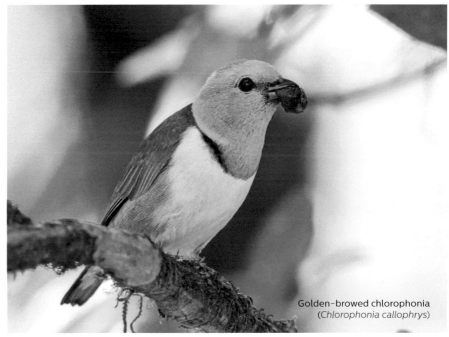

Golden-browed chlorophonia
(*Chlorophonia callophrys*)

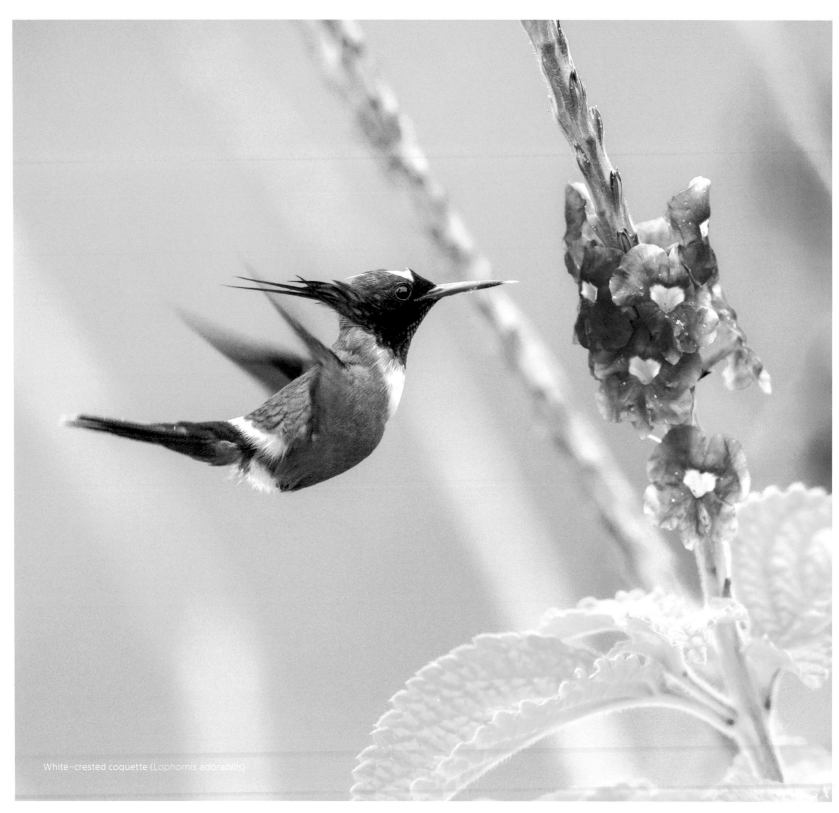

White-crested coquette (*Lophornis adorabilis*)

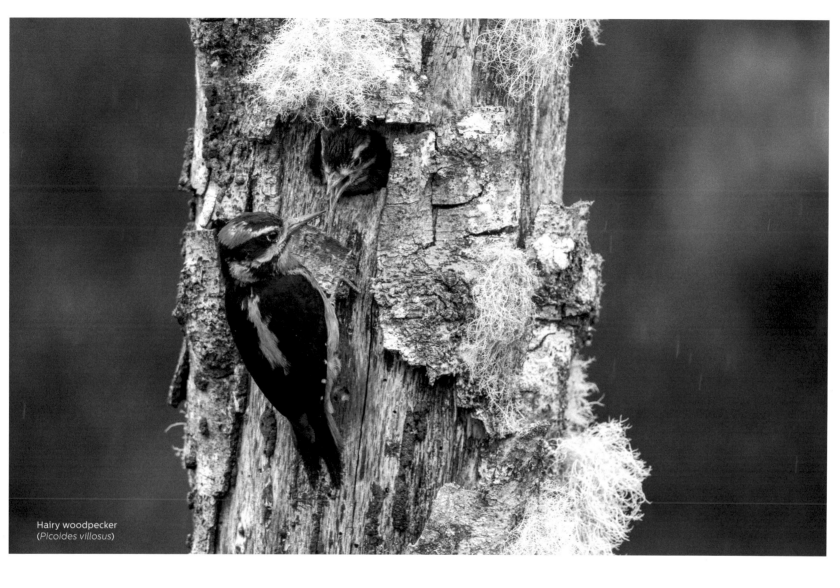

Hairy woodpecker
(*Picoides villosus*)

In complex tropical ecosystems, mountain slopes offer an enormous opportunity for each species to find a niche. The charismatic white-crested coquette, endemic to the South Pacific of Costa Rica and western Panama, prefers lowlands below 4000 feet (1200 m). From there, the hairy woodpecker takes the baton and inhabits the area between 3000 feet (900 m) and the lower reaches of the paramo.

COFFEE PLANTATIONS
AMID THE MIST

The Brunca región was the last in the country to cultivate coffee, but it made up for its tardiness with quality. From the labyrinth of farms in Biolley, Altamira, and Rivas, near La Amistad International Park, comes a type of coffee with complex citrus and floral flavors. In the 21st century, as climate change pushes coffee above the limit of 5000 feet (1500 m), it puts pressure on the highland forests of these mountains and threatens the ecosystems in the area.

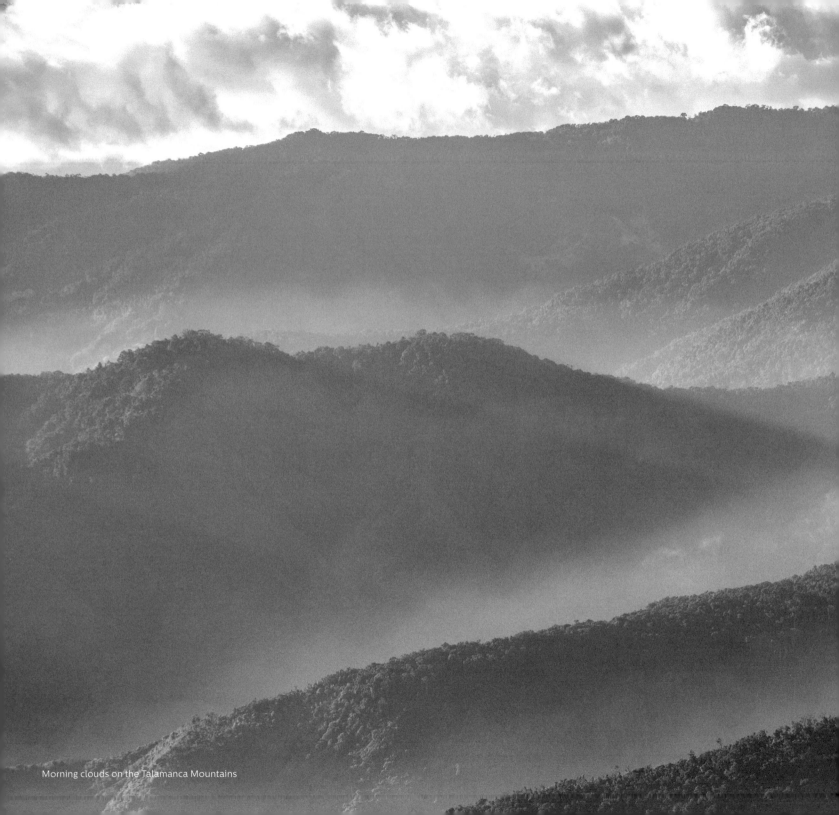

Morning clouds on the Talamanca Mountains

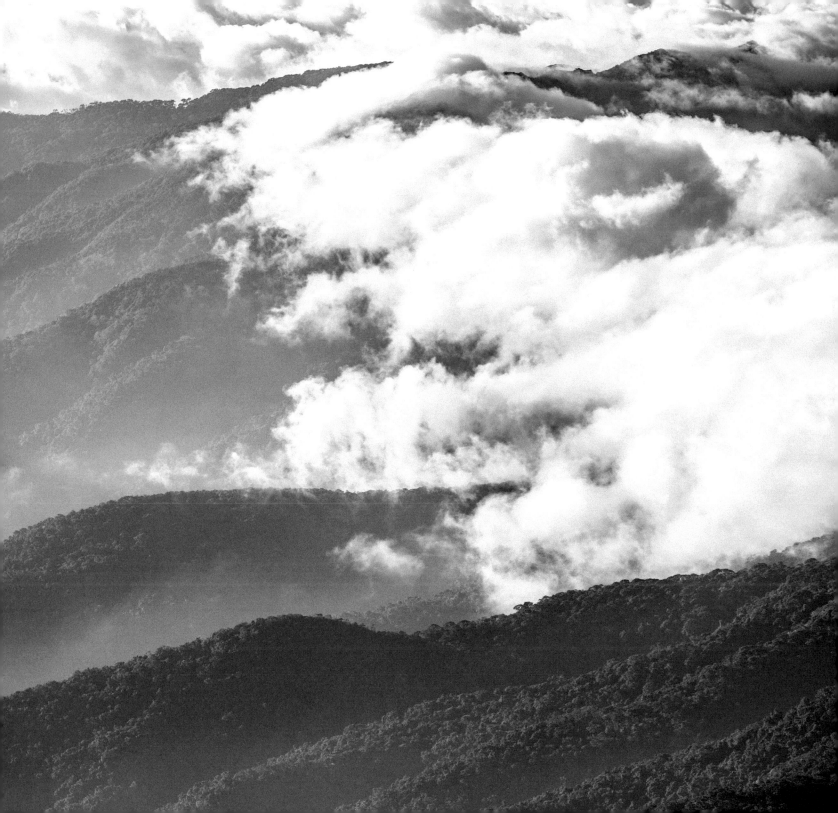

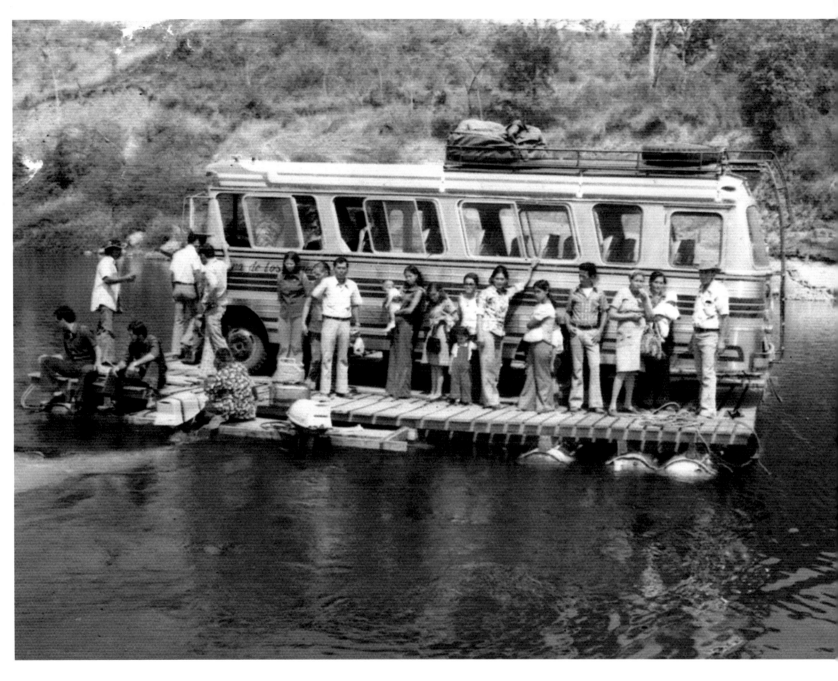

A bus in San Vito fords the Térraba River, in the 1970s (René Villalobos collection).

INDEX

CREDITS

PHOTOGRAPHERS

Unless indicated below, all photographs
are by Luciano Capelli.
Nick Hawkins: pp. 1, 9, 30, 34 (down), 38, 69,73,
83, 84, 93, 97, 99, 100, 102, 104, 106, 109, 112
Jorge Chinchilla: pp. 20, 64, 65, 107, 108
Erick Granados: pp. 81, 89, 90, 91
Manuel Sánchez: pp. 14, 24, 25, 29
Pepe Manzanilla: pp. 70, 71, 76, 96
Bloque Documental: pp. 48, 54, 55
Jeffrey Muñoz: pp. 34 (top), 86, 87
Diego Mejías: pp. 4, 21
Diego Matarrita: pp. 52, 53
Gregory Basco: p. 68
Nāī Conservation: p. 92
Twan Leenders: p. 35
René Villalobos: p. 114

COVER PHOTOS

Luciano Capelli

LAYOUT DESIGN & PHOTO RETOUCHING

Francilena Carranza

LOGO, MAP & ILLUSTRATIONS

Elizabeth Argüello

ORIGINAL TEXT

Diego Arguedas Ortiz

ENGLISH ADAPTATION

Noelia Solano,
John Kelley McCuen

TEXT REVIEW

John Kelley McCuen,
Stephanie Monterrosa

CONCEPT

Luciano Capelli,
Stephanie Monterrosa,
John Kelley McCuen

PRODUCTION

Luciano Capelli,
John Kelley McCuen
Stephanie Monterrosa

ABOUT
THE
PUBLISHERS
—

Cornell University Press fosters a culture of broad and sustained inquiry through the publication of scholarship that is engaged, influential, and of lasting significance. Works published under its imprints reflect a commitment to excellence through rigorous evaluation, skillful editing, thoughtful design, strategic marketing, and global outreach. The Comstock Publishing Associates imprint features a distinguished program in the life sciences (including trade and scholarly books in ornithology, botany, entomology, herpetology, environmental studies, and natural history).

Ojalá publishes illustrated books about the biodiversity and cultural identity of Costa Rica. With every title, we strive to intertwine images and text to transport readers on a voyage through this extraordinary country.

Zona Tropical Press publishes nature field guides and photography books about Costa Rica and other tropical countries. It also produces a range of other products about the natural world, including posters, books for kids, and souvenirs.

COSTA RICA ≈ REGIONAL GUIDES

GUANACASTE

MARIA MONTERO AND LUCIANO CAPELLI

MONTEVERDE & ARENAL

MARIA MONTERO AND LUCIANO CAPELLI

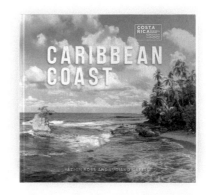

CARIBBEAN COAST

YAZMIN ROSS AND LUCIANO CAPELLI

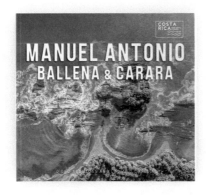

MANUEL ANTONIO
BALLENA & CARARA

DIEGO ARGUEDAS AND LUCIANO CAPELLI

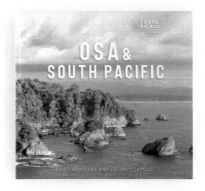

OSA &
SOUTH PACIFIC

DIEGO ARGUEDAS AND LUCIANO CAPELLI

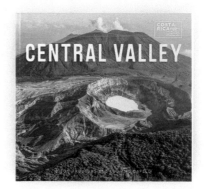

CENTRAL VALLEY

DIEGO ARGUEDAS AND LUCIANO CAPELLI

Principal font: Centrale Sans